PHOTO ART PROCESSES

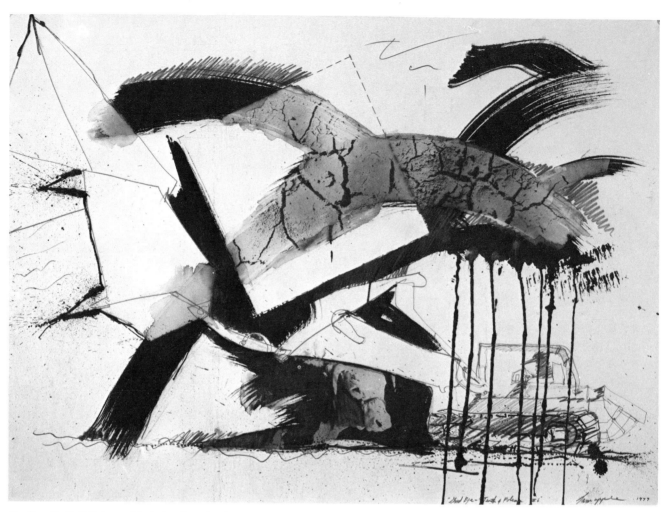

Goodbye Tenth & Folsom, #6. Artist, Sam Apple.
From a series of eight.

PHOTO ART PROCESSES

Nancy Howell-Koehler

Davis Publications, Inc.
Worcester, Massachusetts

Acknowledgments

I would like to thank all of the artists, photographers, craftspeople, art teachers, and students who contributed both their work and ideas to the preparation of this book. Special thanks go to the Educational Staff of the Dayton Art Institute, including the librarian, Helen Pinkney, and to my models Nina Buettner Bliese, Toni McKinney, and Lynn Eder. Richard D. Fullerton of Dayton, Ohio, also merits thanks for generously sharing time and historical photographs.

Thanks for technical advice from Jonathan Kaplan, Bowmansville, Pennsylvania; John Barsness, Madison, Wisconsin; Robert Shay, Columbus, Ohio; Jack Gillen, Oakland, California; Cindy Sagen, Oakland, California; Sam Apple, San Francisco, California; Lon Spiegelman, Los Angeles, California; Ramona Audley, Pewaukee, Wisconsin; Ardine Nelson, Columbus, Ohio; Greg Spaid, Berea, Kentucky; James R. Gilbert, Detroit, Michigan.

Special appreciation to Susan Trewartha, Davis Publications, for her careful editing and faith in the project, to Lizz Studebaker for reading and typing the manuscript, and to K. G. K. for his help and encouragement with all my endeavors.

Printed in the United States of America
Library of Congress Catalog Card Number: 79-53780
ISBN: 0-87192-117-0

Composition: Achorn Graphic Services, Inc.
Printing and Binding: Halliday Lithograph
Type: Palatino
Graphic Design: Jean Hodge

Cover photo: A photo collage on canvas was created by the combination of photo prints and acrylic painting. 30" × 30". Artist, Greg Spaid.

10 9 8 7 6 5 4 3 2

Contents

I

Introduction

The Image in Art

We, more than any other generation before us, live in the era of the photographic image. Photographs surround us—transmitted through the air, projected onto screens, and printed in newspapers and magazines. Via photographs we sell products, educate our children, view our news, and even learn to interpret our own lives. Developing a fresh vision for looking at the photograph is necessary for understanding, interpreting, and ultimately using the photographic image in art.

Photography has always had the unique ability to isolate images from their real environment and suspend them for later reference. This ability has made photography, from its very inception, a visual tool of the artist. It became the accepted, although often disclaimed, method of recording form and perspective, which was later refined into a painting on canvas. However, the expressions of the photographer were thought to be limited by the medium. Although the styles of painting and photography have influenced one another, photography, for the most part, has been regarded as the independent occupation of the artist-photographer and professional picture-taker.

Today, artists and artist-photographers share the same arena. Society's preconceived concept of what constitutes a photograph has been shaken. Photographic images are no longer an end in themselves. A photograph can be the product of a first-hand experience or a later interpretation of feelings or events. Whether the final work is based on a single photograph captured directly, or whether it is the result of several generative processes, it will retain an implication of the original image.

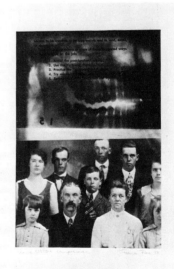

While the implication of the original photograph remains evident, the imagery of *Uncle Otto's Compromise* (5″ × 7″) is redefined in the cyanotype print on a book page. Artist, Felice Fike.

A Flying Person Over San Francisco Bay.
Black-and-white photography by Ted Or-
land, 14″ × 11″. Photograph by the artist.

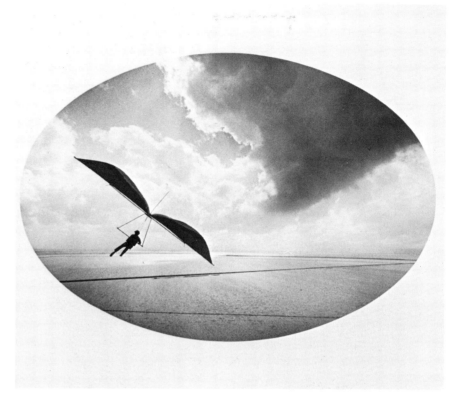

Camera obscura, cutaway view, 1646. En-
graving. Photo courtesy of the Interna-
tional Museum of Photography at George
Eastman House, Rochester, New York.

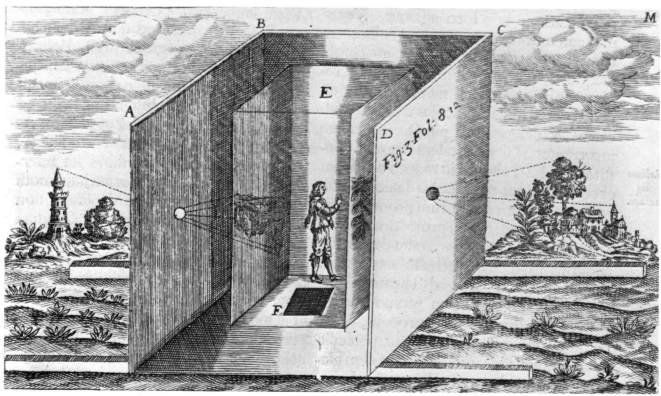

The impact of photographic images lies hidden in their layers of meaning; each layer is relevant to different viewers in different ways. We have become visually attuned to this complexity by viewing images removed from their original pictorial context. Artists such as Andy Warhol have made us uneasily aware of the deception of photographs by filling canvases with silkscreen images of public faces. The approach was reinforced by artists who turned political satirists in the 1960s. "Pop" images were removed from their context and made surreal by their association. Images taken from printed journals and newspapers were reinterpreted visually to simulate real events.

Coupled with this ever-greater influence of photography on art is the expanding accessibility of image making. Photographic technology has placed push-button photography within everyone's reach. Simplified cameras, instant pictures, and public copying machines supply artists with the tools to produce credible likenesses of any conceivable subject.

Thus deluged by a wealth of images, we have begun to reevaluate the potential of photography for personal expression. The photo image can be translated through diverse points of view to expand its implied meaning. Photography is becoming the media for manipulation. Images can be enlarged, cropped, spliced, recomposed, and printed on any surface that best suits the intricacies of the work. Photographs are fluid and constantly changing. No two artists will ever see and interpret a photographic image in quite the same way. This, then, is the challenge of creating with photo images.

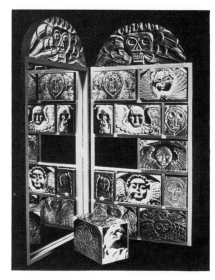

A photo sculpture created from wood, formica, mirrors, paint, and fabric, *Photo Crypt* contains removable, interchangeable photo cubes. 6″ × 15″ × 29″. Artist, Richard Newman.

History of Photo Images in Art

THE DEVELOPMENT OF PHOTOGRAPHY

Not until 1826 did the photograph become a permanent record of an actual image. For 300 years prior to the actual invention of photography, however, image-projection techniques substantially changed the direction of art.

The phenomenon of projected images was known to a tenth-century Arabian scientist. Alhazen of Basra discovered the camera obscura by observing that images are projected from outside into a darkened enclosure when sunlight passes in a straight line through a tiny opening. He used this principle to view an eclipsed sun, whose upside-down image was projected from a pinhole opening in one wall onto the face of an opposite wall. Later, sixteenth-century scientists and astronomers refined the pinhole projection by fitting the camera obscura with a double convex lens. Thus improved, the camera obscura enabled Renaissance artists to trace directly from projected images. Artists such as Van Eyck, Vermeer, Velazquez, and Canaletto used this new tool to achieve faithful representations of proportion and perspective not obtainable by ordinary observation. With this ever-increasing fidelity to nature, realism became the hallmark of painting. Rendering a perfect "photographic" likeness became the goal.

Meanwhile, in a totally different endeavor, a German professor of anatomy, Johann Schulze, was to make a major contribution toward the

discovery of a workable photographic process. Reports of his successful experiments, proving that light-sensitive properties are present in silver salts, were published in 1727.

Some seventy years later, the first recorded attempt to combine the camera obscura with light-sensitive chemicals was made. Thomas Wedgewood had experience using the camera obscura with his father, the famous potter. His interest in light sensitive properties was aroused by the published accounts of Schulze's earlier experiments. Wedgewood endeavored, through several experiments, to print a sensitized surface by projecting images from a camera obscura. These attempts failed. However, other related experiments with silver salts led him to establish the fundamentals of the photogram, by which objects are printed directly in contact with the sensitized surface. Wedgewood placed leaves and insects on photosensitized leather and exposed them to the sun. Resulting patterns printed by these objects could be viewed only by candlelight and soon faded, since Wedgewood was unable to find a fixing agent.

Finally, Joseph Nicéphore Niépce, a Frenchman, produced the first permanent photographic image. His development of a workable system of photography was largely a result of his interest in improving early lithographic printing. By 1826 Niépce had successfully printed a permanent image on a pewter plate using camera obscura projections. Using the heliogravure method, he sought to produce many prints from an original image. He was able to transform a photograph printed on metal into a printing plate by etching the incised lines of the image with acid. He then could make multiple prints from the original inked plate.

Louis Jacques Mandé Daguerre, the famous diorama artist and one-time partner of Niépce, perfected the original process. By 1839 he was able to print a permanent image using a sensitized copper plate coated with a thin layer of silver. This "daguerreotype" plate was exposed in a camera to produce a single mirror-image print. The process at first was slow and

left: American daguerreotype of four men. Approximately 4½″ × 3½″ (quarter plate size). Collection of Richard D. Fullerton, Dayton, Ohio. Photograph by Fullerton.

right: The Straw Stack, an early (c. 1840) photograph on paper by W. H. Fox Talbot, reveals a sensitivity to composition that was well suited to the new medium. Photograph courtesy of the Fox Talbot Collection at the Science Museum, London, England.

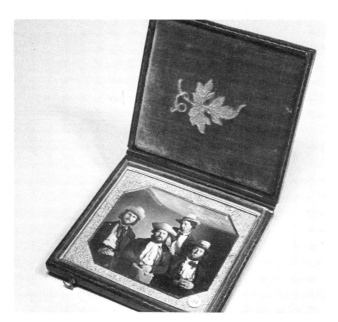

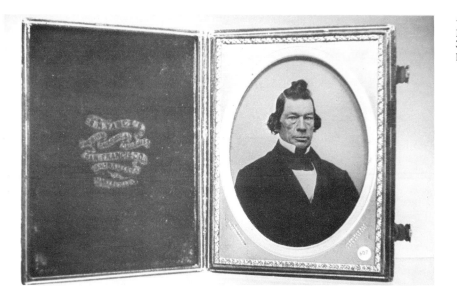

Ambrotype of an important gentleman, probably in San Francisco, c. 1860. 2½" × 3". Collection of Richard D. Fullerton, Dayton, Ohio. Photograph by Fullerton.

unsuitable for portraiture: no human subjects could remain motionless for the twenty minutes required for exposure. Soon, however, improved lenses and a reduction in the size of the original metal plates decreased the exposure time to a more reasonable two minutes. Development and fixing procedures were also improved, allowing photographic portraiture to be pursued as a viable business. This popularized printing process enabled ordinary people to obtain a single likeness of themselves, encased in wood and bound in leather to protect the fragile surface. The portrait painter's position had been seriously challenged.

At approximately the same time, a well-to-do Englishman with a passion for science and a desire to draw realistically discovered a photographic process he called "photogenic drawing." William Henry Fox Talbot was the first to sensitize paper, which he exposed in a camera. The resulting negative image on paper was oiled and used as "film" to print a positive image, the Talbotype. Talbot can also be credited with actually exploring the pictorial range of photography. By taking exemplary photographs that revealed forms and patterns present in naturally lighted subjects, he captured compositions that were particularly suited to the new medium. But since photographs produced by his method were less detailed than Daguerre's, Talbot's process failed to win popular acceptance.

Sir John Herschel, a distinguished scientist and colleague of Talbot's, made the Talbotype negative-position system feasible after he discovered the fixing agent hyposulphite (hypo). With this chemical, paper prints could be permanently fixed, just as they are today.

In addition to discovering hypo, Herschel made other significant contributions to the field he originally called "photography." He printed the first photograph on glass in 1839, and by 1842 he had developed an entirely new process based on the nonsilver ferric salts. This cyanotype process, which resulted in the production of a blue-image print, could be fixed by a simple washing in water. Although the less light-sensitive ferric salts could not be printed by projection, the cyanotype process was to become the foundation of the contemporary blueprint copying industry.

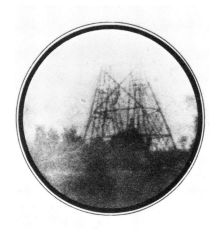

The first photograph on glass made by Sir John Herschel in 1839 depicts the lower portion of a wooden tower. Photo courtesy of the Science Museum, London, England.

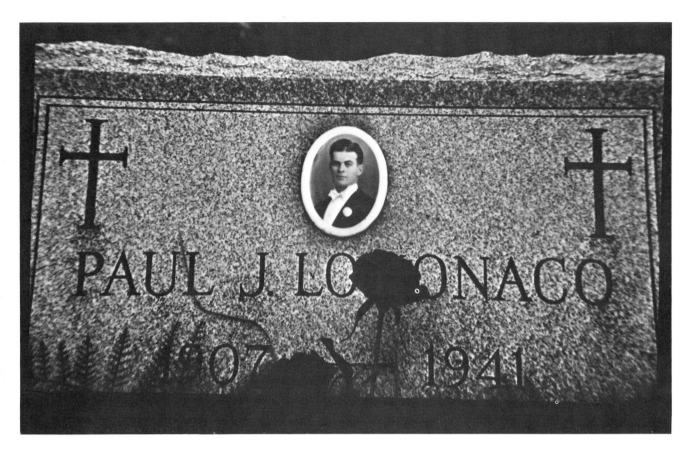

Photoceramic portrait on tombstone, Johnson City, New York. Photograph courtesy of Frank J. Avery.

Turn-of-the-century cyanotype printed on fabric by unidentified photographer. Photograph courtesy of the International Museum of Photography at George Eastman House, Rochester, New York.

The next photographic advancement can be credited to Frederick Scott Archer, the English sculptor. In 1851 he made public, but did not patent, the wet collodion process, in which exposure took only seconds. Wet collodion negatives on glass plates were beautifully detailed, yet less costly than a daguerreotype. The glass negative could then be printed on sensitized paper or mounted against a black background to create the ambrotype. Although the process gained great popularity for portraiture, it was not without flaws. Sensitized plates had to be exposed immediately, while wet, making on-location photography cumbersome and technically difficult.

PHOTOS ON NONPAPER SURFACES

By the mid-1850s, the magic of photography had captured the imagination of the United States, as well as all of Europe. New processes proliferated, and the technology expanded as avid experimenters contributed new methods to image making.

Photographs printed on ceramic pieces began to appear in the mid-nineteenth century. The ceramic photo-enamel process, invented by Dr. F. Joubert in 1860, produced permanently fired images on glass and china. This new application advanced the use of photo images in a decorative, if not always aesthetic, fashion. Photographs adorned china, while miniature portraits were applied to lockets, brooches, and other jewelry. Later, photo-enamels were even used on tombstones.

During this period, photographs were also being printed on sensitized leather, wood, silk, and canvas. The ready market for these novelties was one impetus for producing them. At the same time, however, there remained an interest in both artistically and technically improving the photographic system. No single surface was accepted as the ideal material on which the photographic image could be viewed. Photographs were printed on various materials to enhance their pictorial quality. Leather, as Thomas Wedgewood had proven, could absorb and hold photosensitive chemicals in solution. The same was true of fabrics and some papers, while hard surfaces—such as glass and metal used for the ambrotype and daguerreotype—required a binding agent to hold light particles to the surface. Until gelatin was found to be the ideal binding agent some thirty years later, the search for the perfect printing surface continued.

The tintype emerged from this exploration as the most practical and economical printing surface of its day. Although it was invented by a Frenchman, the tintype was patented in the United States by Hamilton L. Smith. Much to the chagrin of artists who believed photography to be the foremost medium of expression, the tintype, with its dull gray image, became the first photographic folk art form. Similar to the daguerreotype in structure, the tintype substituted an iron plate coated with black Japan varnish (the ''tin'') for the more expensive silver-coated copper plate. Like the ambrotype, the tintype was then sensitized with a collodion just prior to exposure. This cheaper plate composition, plus cameras equipped with multiple lenses enabled early photographers to take up to a dozen exposures on one plate, substantially reducing the cost of photography. The tintype's quality was never equal to that of the ambrotype on glass, but

A tinted tintype of a young woman was encased in gold to create a brooch. Approximately 2″ × 1½″. Collection of Richard D. Fullerton, Dayton, Ohio. Photograph by Fullerton.

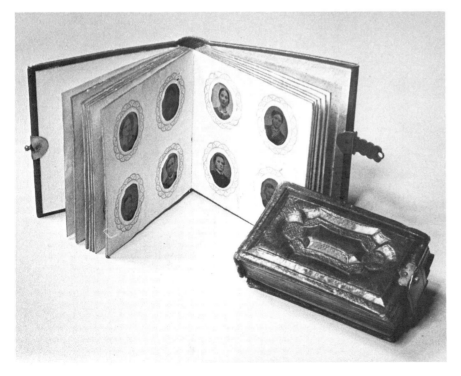

Two early leatherbound tintype albums designed to hold small portraits called *gems*. 3¼″ × 3¼″. Collection of Richard D. Fullerton, Dayton, Ohio. Photograph by Fullerton.

tintype images were available almost immediately. They were less fragile and could be exchanged, mailed, and assembled in photo albums.

Photo applications grew with the insatiable need to own a likeness of oneself or a loved one. With little regard for the quality of the image, miniature tintypes were encased in rings, lockets, and brooches and eventually printed as political buttons. It must have seemed then that a very extraordinary art form had suddenly been swallowed up by an expansive industry.

Nevertheless, technological advancements brought about by the many profitable applications of photography have never dimmed the artist's view of aesthetic potential. The creation and improvement of photographic materials is seemingly endless. The ability to use these materials and processes expressively in large measure depends on a personal commitment to the potential of photography.

Today, artists are reexamining early photo techniques and forms that were discarded in the rush to make photography profitable. Artists working in photo media are applying their knowledge of historical printing processes to creatively interpret photographic subject matter.

The history of photography contains a rich store of ideas and methods for the artist who wishes to combine past techniques with present technology. Several early processes are described in Chapter IV. Further historical information can be obtained from books and articles listed in the Bibliography; sources of materials needed for both old and new processes are indexed in the List of Suppliers at the back of this book.

Near Cabazon, Calif. is a contemporary gum bichromate printed with approximately ten exposures. 24″ × 18″. Artist, Ken Steuck.

II

Designing with Photo Images

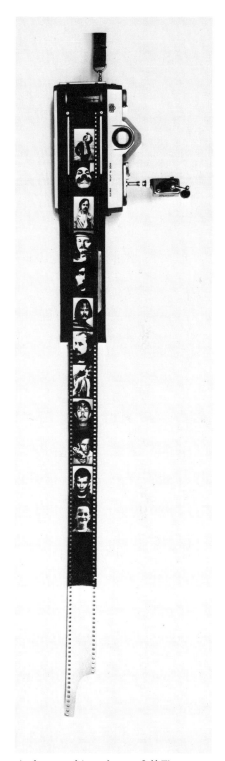

A photographic image can be pictorially powerful. It can illustrate or visually clarify an expression, mood, feeling, or view of reality that another media could only suggest. However, the overuse of photo imagery has tended to dilute this power. Artists who think of incorporating photo images into their work must first consider the design problems involved in this approach.

A photographic image works best in a design when it is vital to the concept of the work. The unity, balance, rhythm, and proportion that may have existed in the original photo should be reestablished in the new relationship between image and material. Failure to accomplish this unification can result in a visual cliché. When a material is used to merely support a photographic subject, the drama of the imagery is destroyed. The artist can usually avoid this type of "object making" by planning the printing surface or material and the photo image concurrently.

Selecting Images for Photo-Art

In one sense, the choice of photo images is somewhat limited by the materials chosen for the design. For example, an expansive landscape would probably not be used in a work of limited size, such as a photo decal. However, because of the variety of processes available for printing photographs, almost any image can be made to fit the design criteria of the envisioned work.

A photographic sculpture, *Self-Timer*, was created from 35mm paper prints mounted in an actual camera. Artist, Steven J. Cahill.

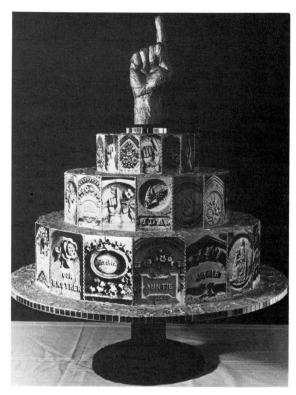

The artist created and used photo decals to achieve a view of reality that indicates our abuse of the environment. A ceramic sculpture from the *Trash* series. Life size. Artist, Victor D. Spinski. Photograph, Raymond N. Kopcho.

Symbolistic imagery in *Funerary Cake* is unified by both form and concept. A photo sculpture created from wood, mirrors, fabric, photos, paint, and sculpt-mold. 26" × 32". Artist, Richard Newman.

PREPRINTED AND FOUND IMAGES

Fortunately, lack of technical experience or photographic equipment need not be a deterrent to the successful use of imagery in design. The accessibility of preprinted photo images invites experimentation without excessive expenditure. Magazines, newspapers, and booklets are sources of photographs that can be easily adapted by transfer techniques to fabric, ceramics, wood, metal, plastic, paper, cardboard, and other surfaces.

Let your imagination range freely through a vast assortment of printed photo images. Images are symbolic. They evoke emotional responses, such as irony, humor, nostalgia, or dread.

Images are pictorial. A combination of images can illustrate ideas that dominate our thinking, showing us in retrospect.

Images can be abstracted. Selected photos can be collaged to provide balance and harmony in a mosaic of line, texture, and color.

Images can appeal to our sense of beauty and order. The awesome vitality of nature, the individuality of people, the art of other cultures—all might become themes for a photo-collage.

Images are personal. Above all, they trigger personal, highly individualized responses that might depict or remind us of ourselves, our problems, our joys.

With found photos as an impetus, the initial idea may grow naturally to include a support material that will enrich the design concept. For example, cutouts from black-and-white photographs, stickers and seals, or even three-dimensional materials might be combined with magazine photos in a photo-collage.

ORIGINAL PHOTOGRAPHS

Unlike found images, original photographs speak directly of the artist-photographer's vision. A personal fascination with the original subject matter depicted in a photo can motivate design expression. This type of photo may already exist in the artist's film file or even in an old collection of family photos. In other instances, the design is planned around a film image yet to be taken.

The photo image best suited to design purposes is quite often the result of a personal confrontation between the artist and a real event, person, or scene. Through the act of photographing, the artist becomes involved with the imagery and is better equipped to expand the experience to its fullest visual limits as a finished work. A single print used as a central theme or "character" can express this concept in some cases. In others, a design that is built around the relationship of several photo images might better communicate the work's identity.

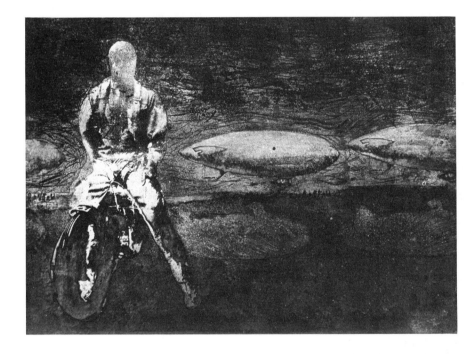

left: In *Lindy and the Blimps*, the artist generated the desired illusion by using only suggestions of a figure and shapes. A print from a photo-etched metal plate. 24" × 18". Artist, Alexander Aitken.

below: Class Piece, a cyanotype-printed soft sculpture, contains enlarged and often-manipulated images created from old class photographs. 2'1" × 1'3". Artist, William G. Larson.

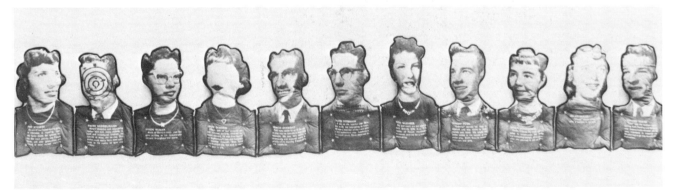

Multiple photo images may be incorporated into a design as a collage and then rephotographed to record the composite. Or, a number of individual but related film images might be printed simultaneously on a sensitized surface to achieve unity. In other multiple-image compositions, photographs are printed separately on a support, such as fabric, and later stitched into a final work.

Photos printed on paper depend on the subject of the imagery to create the illusion of texture in the print. However, when the image is printed on a surface related to the textural character present in the photograph, the image is reinforced. *Tire Tracks,* on the other hand, illustrates how a texture can be emphasized by printing the image on the contrasting texture of shiny satin.

In *Cloud #9*, a cyanotype quilt created from photo images of clouds, the pictorial quality of the images gives way to an abstract pattern of dark and light forms that seemingly float on the fabric's surface. The texture is an intrinsic, yet visually subordinate, element of the work.

A photograph's integrity depends on the original subject matter, the printing process, and the material to which the image is applied. When all factors are working in harmony, the piece achieves unity without sacrificing content. This can be accomplished even when very diverse materials are combined. *New York Clowns*, a neckpiece of fabric with an applied photo decal, illustrates this point. The high-contrast print of the clowns echoes the color and patterns that dominate the fabric neckpiece. The ceramic shape that holds the decal becomes an extension of the neckpiece form, carrying the image into the flow of the design. *(See color section.)*

A design that is to incorporate photo imagery is controlled by technical and aesthetic factors. For every photo considered, there are dozens of

left: Tire Tracks illustrates the textural contrast of image and fabric. 28″ × 22″. Artist, Richard Hubbard.

right: The cyanotype quilt *Cloud #9* uses cloud imagery as a pattern to create a rhythm of darks and lights. 6′ × 8′. Artist, Margot Lovejoy.

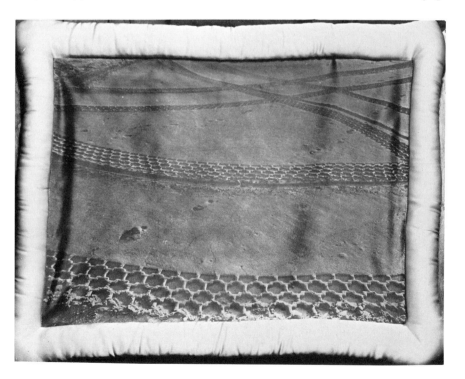

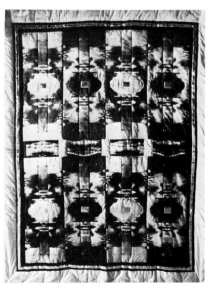

"right" solutions. Choosing a surface to support the image and a process for printing is, in large measure, predetermined by the overall goal set for the work. Once there is a familiarity with alternative printing processes, the techniques required will evolve with the piece. Defining the function of the piece will help narrow the choice of available techniques. Once the design idea has been formed and the printing process chosen, success rests with the artist's ability to reproduce the image or images effectively.

Designing with Multiple Images

Photo-collage and photomontage techniques are used to assemble multiple images in a design. The composite resulting from image assembly may be viewed as a final product; alternatively, it can be considered an intermediate image, to be rephotographed for film enlargement or photocopied for transfer printing.

THE PHOTO-COLLAGE

The art of photo-collage was perfected by German artists of the post-World War I Dada movement, who used the technique to express their disenchantment with society by questioning traditional forms of art. Dadaists were expert in composing radical collages that juxtaposed the real with the fanciful and exchanged order for chaos. A photograph was collaged to supply credibility to their vision of the world.

A photo-collage is composed of portions or fragments of photographs secured from many different sources. Preprinted magazine images might be combined with actual photographs, drawings, prints, photocopies, or

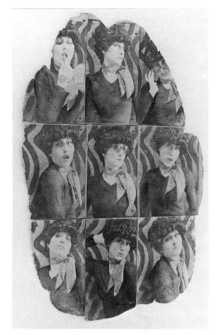

To create *Confrontation with Illusion*, a series of images were projection-printed directly onto emulsion-coated clay. 14" × 24". Artist, Mary Ann Johns.

A cyanotype printed on fabric acts as a backdrop for the electrifying photograph mounted as a foreground event. 21" × 12½". Artist, Tom Petrillo.

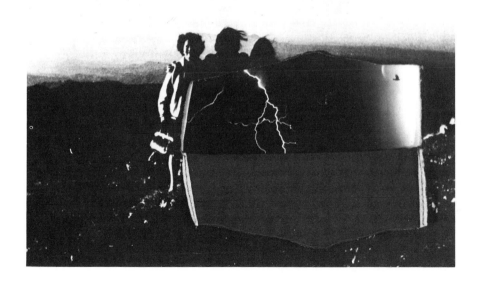

In a unique approach to photo-collage, the artist has combined both flat and three-dimensional materials by staging them before a camera equipped with a macro lens. 10″ × 8″. Artist, Carla Steiger.

Using a similar approach to collage, another artist staged three-dimensional materials on the glass of a black-and-white copy machine. In this case, the final print is a black-and-white photostatic copy instead of a photographic print as in the previous illustration. 8″ × 5″. Artist, Jack Perkins.

even exposed film to create a rich pattern of textures and imagery. However, collecting images to express an idea is not the sole design consideration.

The surface on which photo images are placed must also contribute positively to the concept of the work. Harmony is fixed through the thoughtful placement of design elements in relationship to the background material. For example, if a glossy photograph is positioned next to a roughly textured section of painted canvas, the image is dramatized by the opposing textures. Such apparent discontinuity in surfaces can be used to hold and direct the observer's eye, enabling the work to be viewed in its entirety.

Diverse textures, such as fabrics and photographs, can be unified by subject matter as well as design placement. This type of solution is apparent in the work of Tom Petrillo. A cyanotype image printed on fabric acts as a backdrop for the electrifying photograph mounted as a foreground event. Tension is created by the textural differences playing against the images.

Proper balance between foreground and background elements is often difficult to maintain when several images from different sources are to be applied to yet another surface. A slick color photograph from a magazine and a grainy newspaper print can have common content, but they may be visually confusing because of their very different printed qualities. This problem is remedied by photocopying all images in black and white before they are collaged. In this way, textural and tonal continuity are created by the copying process, making the joining of separate images more convincing. This technique might be extended to include the color copying of a completed collage. The result will be a second-generation copy that retains the tone and detail of the original copy while producing a uniform, smooth-surfaced print.

Because an infinite variety of images and materials could conceivably be combined in one collage, construction techniques can vary greatly. Historically, artists produced photo-collages by gluing the components onto a flat illustration board. Today, this type of application is only one of many. Collages can contain materials that are nailed, stapled, molded, bonded, transferred, stitched, snapped, laced, or otherwise applied onto adjoining surfaces. The design is best served by the technique that will contribute most to the form and context while substantiating the image. A photo-collage need not be limited by a flat surface. Images can be transferred to three-dimensional forms, or they may be printed directly on any material that can be coated with a photographic emulsion.

THE PHOTOMONTAGE

A photomontage is a composite photograph created when two or more separate photographs are cut and combined in a jigsaw pattern to create an illusionary or surreal print. A photomontage is distinguished from a photo-collage in that it is a composite printed exclusively from photo images taken by the artist. Although these terms have often been used interchangeably, in this book they will retain their distinct definitions.

Creating photomontages has fascinated artists from the very inception of photography. The ability to extend "real" vision by constructing images

First Spring. Photomontage. 11″ × 14″. Artist, Jack Breit.

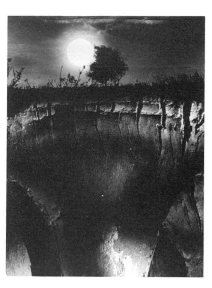

that deal with the symbolic and the fanciful appeals to the adventurous spirit. The unseen becomes seen, and the photograph loses its strict representational quality. The artist is free to experiment with photographic shapes, forms, lines, patterns, and textures by interrelating them as elements in design without sacrificing the continuity of the photographic medium.

A photomontage is constructed by the artist who recognizes underlying relationships among objects, places, and events. The artist is motivated to combine the photographic components to represent his or her vision. For this reason, the art of photomontage bears the artist's personal imprint. A photograph taken of the human figure can be a superlative representation without being a definitive work. Yet, when a single portion of the figure is separated from the whole, the body's shape takes on new meaning. The artist's vision is further augmented by the placement or repetition of this form within a new composition.

The repetition of a single image from a photograph is one possible direction to take, but more often the montage is created from several photos that are visually or conceptually linked with one another. The initial idea can be inspired by a photograph that jolts the memory or triggers the imagination. One photograph may provide a background on which events and persons are superimposed, while another photo might be reduced to a single, isolated image. The number of separate images used in combination depends solely on the composition.

Meticulous planning is a prerequisite for the production of a workable composite. Individual components must be skillfully combined to retain the feeling of one actual photograph, and these components should be carefully aligned as a total composition before they are cut. You can test a composite design by tracing all images onto thin paper. This working drawing of the final print will help you determine the cutting lines along which to join the images. Before you mark and cut, note the following:

Cutting lines that follow the outline of an object are most inconspicuous.

Zigzag edges help disguise joints when they are trimmed from a patterned photograph.

Straight lines should be avoided unless they follow the shape of a depicted object.

When the drawing of the composite has been finalized, the images can be cut from the photographs along the lines indicated by the tracing.

Because photographs are composed of two distinct layers, paper and emulsion, a very sharp tool such as a single-edged razor blade or an X-Acto knife is needed to ensure a clean cut. Working from the front, the photograph is cut with an inward slant so that the paper under the emulsion layer can not be seen from this side. After cutting, the paper edge is rubbed gently with fine sandpaper until it is thin and smooth. The emulsion layer should extend over the paper edge. It can now be almost invisibly joined to another section. Before the pieces are combined, all edges should be colored with a shade appropriate to that of the local area of the composite. Water-soluble marking pens are used for this purpose. After the coloring is complete and the edges appear to join invisibly, the individual images can be applied to a common surface with an even coating of rubber cement.

To assemble a photomontage: (a) Cut individual pieces from photographs and color the cut edges with a shade appropriate to the tone of the local area of the composition. (b) Apply the individual images to a common surface with an even coating of rubber cement, and then photograph and print the completed montage.

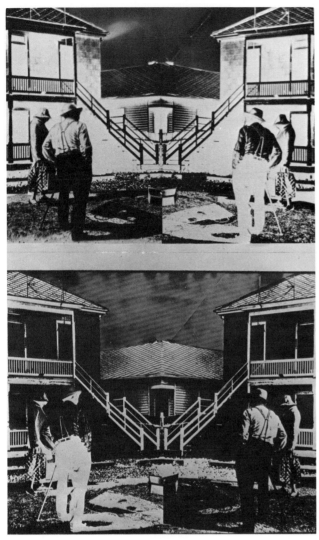

A photomontage can also be created by collaging graphic arts film. The cut film is held together with clear tape and printed in contact with a sensitized surface as in *Galveston Astigmia*, a gum bichromate print. 15½″ × 12½″. Artist, Evelyn Behnan Bell.

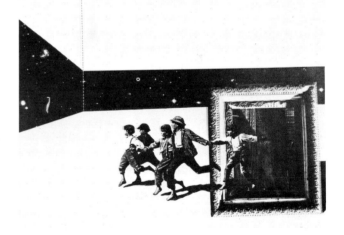

Plenty of Space to Romp. Photomontage. 14″ × 11″. Artist, Don Fike.

Other types of photomontages are created directly in the darkroom. Some are the result of multiple exposures, carefully planned to create an overlay of imagery. Others are the product of masking, printing, and remasking until several distinct image areas are printed to form a composite. Alternatively, a montage can be produced in the film stage when graphic arts film enlargements are to be used for contact printing. In this instance, pieces of film are spliced with opaque or clear tape, depending on the background color of the film. The film composite is then ready to be printed as a photomontage on a sensitized surface.

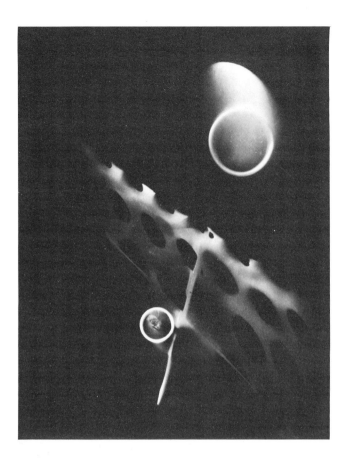

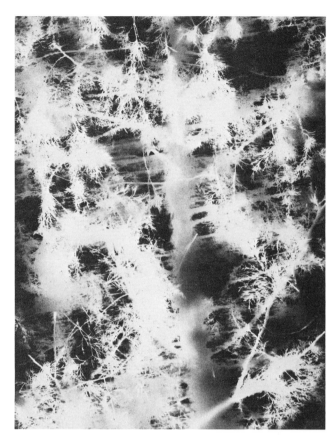

left: Photogram or light painting by Bauhaus photographer Laszlo Moholy-Nagy. Photograph courtesy of the International Museum of Photography at George Eastman House, Rochester, New York, and used with permission of Hattula Moholy-Nagy.

right: This direct photogram, exposed by propping a large sensitized sheet upright in a tree from 12 noon to 12:30 each sunny day, is part of the year-long *Tree Series*. Cyanotype. 28″ × 40″. Artist, Martha Madigan.

The Role of Film in Photo-Art

FILMLESS TECHNIQUES

As the artist begins to consider design applications, he or she is immediately faced with determining how the image can best be printed to enhance the work. Although at this point the individual with little knowledge of photography may feel overwhelmed, the desire to print a photo image on various surfaces need not lead immediately into the unknown. By first experimenting with simple filmless techniques such as printing a photogram, the artist can more easily understand the limitations of a particular photosensitive surface. Once simple photogram techniques have been acquired, the investigation of more complex film printing processes begin to evolve naturally.

The Photogram

The photogram is one of the simplest, most direct techniques for printing images without a camera. A photogram is made when an opaque or semi-opaque object is laid on a photosensitive surface and exposed to a light source. The object blocks the light where it is positioned so that, when the print is developed, a white silhouette of the object appears on a dark background. This negative image produces a form or shape that is not necessarily representative of the original object. In this sense, the

photogram abstracts images. Everyday objects can become extraordinary shapes. Form, line, and texture become apparent. Seen as photo images, shapes emerge as rudimentary design elements.

The Bauhaus photographer Laszlo Moholy-Nagy can be credited with substantially advancing the photogram as an abstract art form. He believed a photogram to be a light painting, and he illustrated his belief with an outstanding series of photograms in the 1920s. His printing techniques were based on the theory that, even though photosensitive material was flat, it could be made to yield three-dimensional representations—even in a cameraless print. Moholy-Nagy "painted" the photosensitive surface by directing beams of light on objects from different angles to cast shadows. The flexible light of a flashlight gave him complete control over surface exposure, which enabled him to create the illusion of depth he desired. His photogram images seemed to appear out of pure space, taking form before the viewer's eyes. This dedication to three-dimensional space preceded by decades a similar effect now achieved by computer artists.

The sense of depth in a photogram can also result from the actual structure of the objects chosen. When an object that contains varying degrees of opacity is printed, a variety of thick and thin areas will appear in the final print without the need for light manipulation. The print, exposed in direct sunlight or an overhead light source, produces different tones as the light penetrates the varied densities of the object.

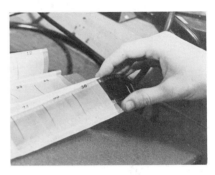

The simulation of motion is still another visual illusion that can be created with the photogram. This technique requires that objects be moved slightly during exposure, thereby creating a light shadow of their original position printed next to the primary image. When the object is moved very rapidly, blurring will occur. To allow time to capture a "slow-motion" sequential effect, a slow-speed sensitizer such as cyanotype is used. The object is then moved over the sensitized surface, according to predetermined time increments. Exposure time will vary according to the effect desired. For a realistic sense of motion, the first photogram print is begun several inches away from where the primary or final image is to be placed. After the first, very short exposure, the object is moved gradually, in short steps, and the exposure is increased for each print until the final image is printed. With this technique, faint images grow more intense, appearing to move across a surface.

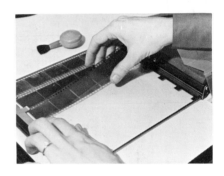

Although image abstraction is one of the more intriguing techniques, photograms are by no means limited to the production of nonobjective images. When uniformly opaque objects are printed with direct light, a perfect silhouette of the original is reproduced. This, of course, is ideal when an object can be recognized in silhouette. The realistic approach is evident in the neckpiece shown. A Vandyke-sensitized fabric was printed in contact with the opaque letters at the left. The cut letters were held in tight contact with the printing surface and exposed to obtain a shadowless print.

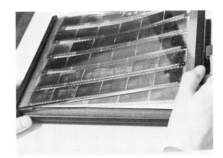

Three-dimensional objects can also be printed to yield a uniform white image when they are exposed by a light source directly overhead. The object, however, must be heavy enough to make total contact with the printing surface. A shape silhouetted in this manner provides the viewer

To contact-print 35 mm film: (a) Clean the glass on the contact-printing frame. (b) Remove the film from protective sleeve, and use a brush blower to remove dust particles. (c) Slip negatives into the holder, shiny side against the glass. (d) Using only a safelight, place the photographic paper under the negatives (emulsion to emulsion) and expose it to direct light.

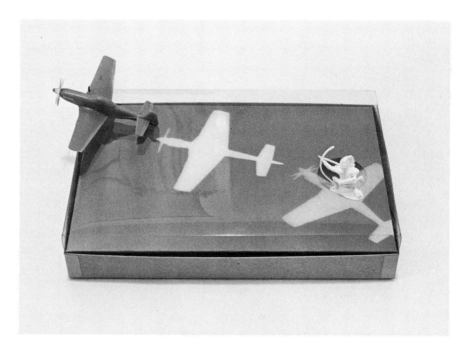

In *Untitled,* the artist used photogram prints to create a background of action against which the foreground characters are played. Cyanotype photogram, toys, vinyl, and cardboard box. 11″ × 7½″ × 4″. Artist, Michael Stone.

with a recognizable symbol and may help the artist communicate an idea that would become too visually complex if an ordinary photograph were used.

The photograms seen in the work of Michael Stone have a strong ability to express ideas. The integration of the actual object whose photogram image is depicted deepens the contrast between textured and nontextured, real and simulated. When tension is produced between foreground and background imagery, the feeling of action becomes immediate.

A photogram is a monoprint, so no two prints will ever be exactly the same. Nevertheless, this does not eliminate the need for preplanning. Images intended for design should be test-printed on photographic paper. The speed of the final sensitized surface may vary greatly from the paper, but the initial printing will give the artist an opportunity to experiment with imagery and make changes that will help resolve design relationships before the final exposure.

A photogram can help qualify sensitivity and determine exposure time of unknown photosensitive surfaces. It can acquaint the uninitiated with darkroom procedure on the simplest level. Photograms are inexpensive to print, requiring only a darkened room with a direct light source, trays of developer, fixer, and water, and photographic paper or photosensitized material. Numerous household, mechanical, and natural items can be used in printing.

FILM REQUIREMENTS

Film is the intermediate product of image making that carries the quality and the content of the photographic print. For this reason, film images with full tonal range are essential for reproduction. Poorly exposed or composed film is time-consuming to correct and usually will produce less satisfying results.

When black-and-white film has been exposed in a camera, it must be processed by developing, stopping, fixing, and washing to produce a negative image that can be used for printing a positive image on a photosensitive surface. However, individual strengths and weaknesses are difficult to discern on the negative. You can conduct a superficial evaluation of a film's potential by holding the film to light to observe its density. You can then make a contact print to verify your findings.

Contact prints are made by placing strips or sections of film on photographic paper. The film and paper are sandwiched in a contact printing frame or covered with a heavy glass so that the film is in close contact with the photosensitive surface. After a few seconds' exposure under a bare light bulb or the direct light of the enlarger, the paper is developed in the recommended solution, fixed, washed, and dried. Images can then be viewed for the first time as positives.

The size of the contact print is determined by the size of the original film, so the contact print is quite small when 35mm or other small-format film is used. A magnifying glass is useful for making image selections for later printing and processing.

If you want a print of a larger, more intelligible size, the film negative can be enlarged. Once enlarged on photographic paper, you can evaluate the quality of a photo image before it is printed on a nonpaper surface.

Surfaces coated with high-speed photosensitive emulsions may be printed from a small negative by projection enlargement. Such surfaces include photographic papers, spreadable photo emulsions, and graphic arts film. Surfaces containing slow-speed sensitizers such as cyanotype *cannot* be printed by projection enlargement, but rather must be contact-printed. A negative film enlargement must be made, therefore, before the image is printed.

If you want to experiment with contact printing without taking photographs or paying for an enlargement, you can investigate sources of discarded film. Newspapers and other printing establishments that use offset

Discarded pieces of exposed film can be obtained from newspaper offices or printing houses to create a composite for contact printing.

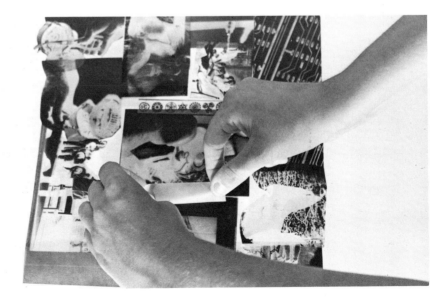

printing presses are potential sources of exposed sheets of film. Even though the images are interposed with text, the film can be easily cut and collaged. The simplest approach is to arrange individual pieces of film on a sensitized surface, cover the surface with glass, and expose it to light. For even more control over the final print, cut film can be secured with clear tape in the desired position to a sheet of clear Mylar or acetate. This method makes the constructed film easier to handle.

Another technique for constructing film can be found in Chapter III, in the section "Acrylic Transfers on Acetate." In this method, images cut from magazines are transferred onto clear acetate and then contact-printed to yield a negative image.

Film Enlargement

Procedures for making film enlargements vary with the types of film and techniques chosen for reproduction. These methods are covered more fully in the accompanying chart, but the basic procedure is as follows: A black-and-white film negative is placed in the enlarger. The projected image is printed as a positive on graphic arts film. After processing, the positive film enlargement is contact-printed onto a second sheet of film to yield the full-sized negative film necessary for contact printing on a slow-speed sensitized surface.

When darkroom facilities are not available, you can have negatives enlarged professionally. This work can be done by local photoprocessing labs; several sources should be contacted so you can compare prices and quality of reproductions. The enlargement will represent an investment, so it is important that the technician who enlarges the film understands what is desired. An enlargement might be done as a continuous tone with high contrast, or as a halftone (dot-pattern) image. Written instructions should accompany the original film. When you don't know what type of image would be best suited to a particular purpose, consult a photo technician.

The methods for creating film enlargements outlined in the chart require a basic darkroom setup plus graphic arts film and the recommended developer. Because a number of types of graphic arts film are available for film enlargement, however, the attributes of each film should be compared before an enlarging method is chosen.

The three steps necessary for creating an enlarged negative for contact printing. The first enlargement, at left, is a film positive, projection-printed from the 35mm negative. A full-sized negative is then produced by contact printing the positive onto a second sheet of film. The final print is made by contact printing the negative onto a photosensitized surface (in the case, photographic paper).

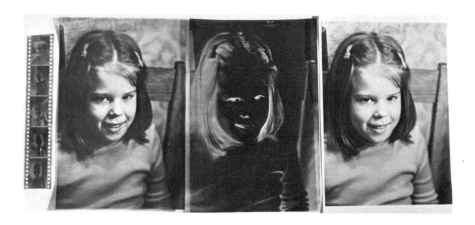

Methods for Creating Film Enlargements*

Methods	Original film	Advantages	Disadvantages
1. Enlarge image directly onto High-Speed Duplication Film (Kodak type 2575).	b/w negative	One-step procedure. Good-fidelity reproduction.	Film more expensive. Limited to production of tonal range present in original image.
2. Enlarge image onto ortho-type film or Kodak Fine-Grain Positive. Use the resulting positive enlargement to contact-print the full-sized negative onto a second sheet of film.	b/w negative	Good-fidelity reproduction. Both positive and negative enlargements usable for printing. Good method for producing high-contrast and Auto-screen images.	Requires additional film for intermediate positive.
3. Contact-print a negative onto graphic arts film. Enlarge the resulting positive on full-sized sheet of film to make negative.	b/w negative	Less film needed, so more economical.	Some loss of quality because of successive printing.
4. Enlarge positive color film directly onto ortho or other type graphic arts film.	positive transparency (color slide)	One-step procedure; easy and economical.	Color film printed in b/w will suffer loss of quality and details.
5. Expose photographs on film that can be converted to positive images by developing with a kit (Kodak Direct Positive Development Kit).	expose film: Kodak Direct Positive Panchromatic Film (5246) or Kodak Panatomic-X	Original becomes positive from which enlargements are made.	Films for this purpose are limited. Negative film cannot be converted after conventional development. Multiple-step development time-consuming; kit costly.

These methods are intended for creating a negative enlargement for contact-printing a positive image. Positive enlargements are made as described in the first step of method 2.

Graphic arts film can produce a high-contrast image, or an image with continuous tone. The method of developing the film depends on the image chosen and the print desired. (a) A high-contrast negative and resulting print; (b) a continuous-tone negative and resulting print.

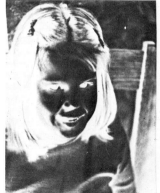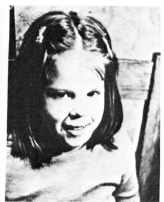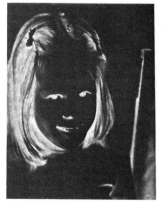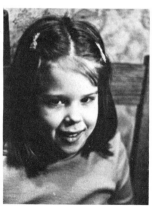

Processing setup for graphic arts film: three trays containing developer, stop bath, and fixer; running water in large tray for washing; final, optional tray filled with a film-rinsing agent.

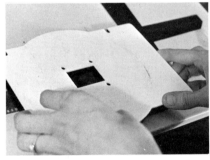

To create an enlargement on graphic arts film: (a) Load small-format film into the film carrier.

(b) Place the film carrier in the enlarger.

Graphic arts film, unlike ordinary film, can be handled in a safelighted darkroom in the same way as photographic papers. Commercial art stores and graphic arts suppliers carry a variety of graphic arts film, which can be purchased in various sheet sizes and by the roll.

Ortho film (Kodalith, type 3) is one type of graphic arts film widely used in the printing industry. This film's ability to convert normal tone range images into high-contrast film enlargements is its most notable feature. However, ortho film is not limited to the production of high-contrast film for printing. Photo images enlarged on ortho film will vary in contrast according to the developer used for processing. A high-contrast print is produced from a normal negative when the recommended (AB) developer is used, whereas a normal or continuous-tone film enlargement can be obtained from the same original when ortho film is processed in a regular paper developer (Dektol). If a halftone photo is desired, Autoscreen ortho film should be selected. This film has a built-in line-dot pattern that automatically produces halftone images from normal continuous-tone film.

In addition to ortho-type films, Kodak manufactures Fine-Grain Positive Film (type 7302), which is less expensive than other graphic arts film. This film is suited to the production of continuous-tone images (it duplicates the original film's tonal quality). It is processed with inexpensive paper developer (one part Dektol, seven parts water) and can be purchased in sheets up to 11″ × 14″ in size.

Kodak High-Speed Duplicating Film (type 2575) is perhaps the most unusual of all graphic arts films in that it can produce a negative enlargement from negative film. This special attribute eliminates the need for an intermediate positive from which the final negative is printed. Although type 2575 film is more expensive, less film and time are required for this procedure.

Printing and Processing Film Enlargements

Graphic arts film is processed by means of procedures similar to those used for making enlargements on photo paper. A knowledge of basic darkroom procedures will prepare anyone to work with graphic arts film. However, film must be handled somewhat more carefully than paper is. Dust particles in the air represent a constant threat to film enlargement. Flawless reproductions can be obtained only when the original film is free from smudges, dust, scratches, cracks, and drying streaks. Most of these problems can be avoided with reasonable handling. You can remove dust before printing by wiping the film with a *soft*, natural bristle brush. You can also use an aerosol film cleaner. Regular lens paper is needed to remove smudges from the shiny side of film, but damage to the film's dull emulsion side is generally irreversible. Clear spots apparent in a negative enlargement can be touched up with opaque film paint and thin-bristled touch-up brushes.

Use standard darkroom equipment. This includes three appropriately filled processing trays large enough to accommodate a single sheet of film, arranged in the following sequence: developer, stop bath, and rapid fix. You will also need running water with a washing container and you should provide an optional fourth tray containing Photo-Flo (a product to aid in the streak-free drying of the film) at the end of the sequence.

You can find information on the original film required, and a guide to the different types of graphic arts film for enlargements in the chart on page 29. To make an enlargement, load the small-format film (black-and-white negative, color positive, or contact-printed film positive) into the film carrier with the dull emulsion side down and place it in the enlarger. Operating with only a safelight, turn on the enlarger with the lens adjustment fully open. Place an easel, adjusted to the desired film size, under the enlarger. Raise or lower the height of the enlarger to project the image directly on the easel that will hold the film. Focus the lens to sharpen the image within this area.

With the enlarger lens stopped down (partially closed), set the exposure time accordingly. If the lens is closed down so that the projected image is barely visible, the exposure time must be lengthened. The reverse is also true: an image projected through a large lens opening will require a shorter exposure time.

You can determine the ideal settings only by test printing. When a film has previously been enlarged on paper, the setting and resulting image will provide a prototype. Supplied with the exposure time from the original paper enlargement and specific information supplied by the film manufacturer, you can make an intelligent estimate of the exposure time for printing on film.

To determine the exact setting for a desired print quality on film, you must expose a test strip cut from a larger sheet of graphic arts film. The test strip should be large enough to accommodate a recognizable image and should cover approximately one-third of the projected image area. It should be positioned to include critical areas of the image as well as a representative sample of tones to be printed.

(c) Adjust the height of the enlarger to project the image size desired.

(d) Focus the lens to sharpen the projected image.

(e) Stop down the lens according to the optimum focal length.

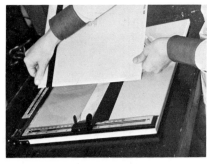

To print a test strip on film: (a) Place a piece of film that covers approximately one-third of the image area in the easel under the enlarger. Using a piece of opaque cardboard, expose the film a section at a time by progressively uncovering the film at 5-second intervals during the exposure. (b) Process the film. The 25, 20, 15, 10, and 5 second exposures will provide a guide to the correct exposure range for your enlargement.

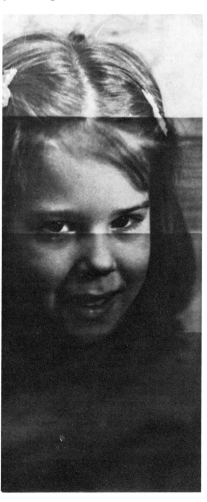

Using the safelight only, secure the test strip in the easel, with the light-colored emulsion side up. Then expose the test film, a section at a time, by uncovering it with a piece of opaque cardboard. As the cardboard is moved bit by bit over the surface of the film, increased amounts of light will expose each area. After processing according to instructions supplied by the film manufacturer, study the test strip in full light. If the expected results have not been achieved in any of the exposed areas, you can run a second test with a different lens opening and/or time setting. Once the optimum setting has been realized, all other factors are held constant. The film enlargement is made with the predetermined setting and processed with the same time, temperature, and chemical strength used for the test.

It is imperative that you read and understand the fact sheet accompanying the film when you work with an unfamiliar product. Each film has its own peculiar traits, which are pertinent to successful processing. An obvious example is High-Speed Duplicating Film (Kodak type, 2575). Because this film has been preexposed to enable it to produce a negative image from negative film, it works totally opposite from other photosensitive materials. A pale image on this film indicates overdevelopment, whereas an underdeveloped image will look too dark. This factor will cause confusion if you are not familiar with it.

A halftone line-dot image, so vital for silkscreen, offset printing, and photoetching, is produced when ortho film is used in conjunction with a halftone screen. The halftone screen converts the continuous tone of a normal photograph into a predictable dot pattern. This pattern retains the details and texture of the original photograph, which would otherwise be lost in these three printing processes. The expense of purchasing a halftone screen, however, should be warranted by the need to produce a great many halftone images. Many artists find that Autoscreen, an ortho film with a built-in line-dot pattern, is more economical for printing halftone photos.

An even more economical procedure is to create a random dot enlargement with Kodalith ortho film, using another type of developer. Random-dot film images may be substituted for halftone images in processes that require halftones. Unlike halftones, these images do not contain a predictable line pattern, but the random black dots of various sizes and shapes make it possible to retain intermediate grey tones in essentially the same way.

A random dot image is produced when Kodalith ortho film is developed in Kodalith Fine Line AB Developer. You can enhance the dot pattern by using grainy negatives for making the enlargement. Good technical control is also important to the success of random dot enlargement. Maintain the temperature of the Fine Line Developer at 70°F. Place fresh developer in a flat developing tray and agitate the print for only fifteen seconds, then allow it to develop for two minutes. The developed film is then stopped, fixed, washed, and rinsed in the usual manner.

Paper Film

The expense of purchasing a quantity of large-format film for one enlargement can be discouraging. Depending on the process involved, the expenditure for chemicals, sensitizing substances, and film can become

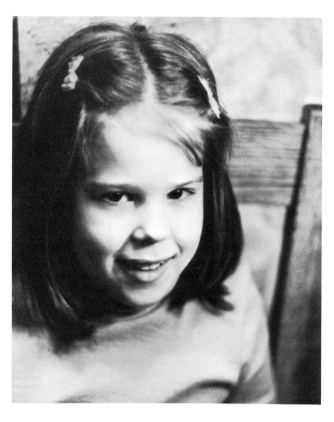

left: (a) Halftone photographs are created when regular ortho film is printed with a halftone screen or when printed directly on an autoscreen film. *above:* (b) Close-up of halftone dot pattern.

below left: (a) A random dot image can be obtained by special development of a grainy negative enlarged on graphic arts film. *below* (b) Detail of random dot pattern.

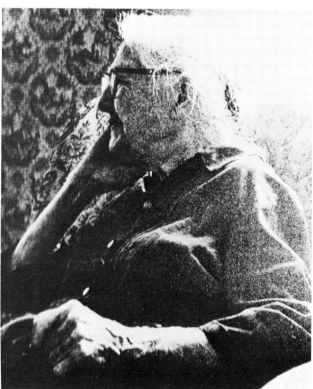

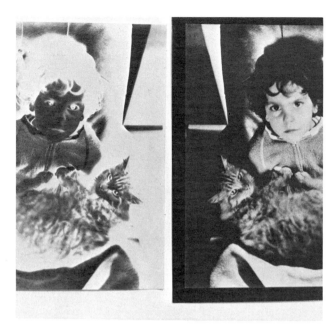

left: (a) A paper negative enlargement made from a 35mm color positive film. (b) The resulting contact-printed positive.

right: After several coatings of oil, a paper negative becomes relatively transparent, resulting in improved detail in the final print.

prohibitive. When overall cost is a deterrent to the successful completion of an idea, less costly paper film can be substituted for graphic arts film.

The use of paper film is not new. Before Kodak combined transparent base material with the photographic emulsion, paper was sensitized and exposed as film inside the camera. After the exposed paper negative was processed, it was coated with oil until the paper became semitransparent. The paper negative could then be printed in contact with a sensitized surface to produce a positive print.

This procedure has fallen into disuse since the advent of fast film. However, the paper negative does provide an alternative to contact printing photo images when sharp, detailed reproduction is not necessary.

Today, paper negatives are created when a color positive film or a black-and-white positive film (contact-printed from a negative) is projected onto photographic paper. This method is essentially the same as that used for printing a regular paper enlargement, except in this case a negative image is produced on the photographic paper.

Photo images printed with paper negatives have a distinctive character. Both the texture of the paper and the image will be reproduced when the positive print is made. For instance, a single-weight photographic paper will produce more texturing than a resin-coated (RC), medium-weight photo paper that is more opaque and consequently takes longer to contact-print. Each photographic paper will vary slightly, so you should test several types to determine their reproduction fidelity and texturing traits.

Creating Paper Film

Photographic images selected for paper negatives should exhibit clear detail and excellent contrast. Photos that normally would be considered to have too much contrast will work well when printed as paper negatives.

A film positive is required to print the enlarged negative images on

photographic paper. This may be a small-format color positive (slide transparency) or a black-and-white film positive, contact-printed from an original negative.

The film positive is placed in the enlarger and the image projected onto the photographic paper; the negative paper print is processed according to instructions supplied by the manufacturer.

When a film image of normal contrast is used, the photo may be printed on high-contrast paper to ensure that the negative will produce a well-defined image when used for contact printing.

After the paper negative has dried flat, it can be treated with oil to make the photo paper more transparent. This procedure is simple, but it will require several thorough applications of oil (clear cooking oil, castor oil, or the like) to produce an even transparency. The oil is spread generously over the entire face of the paper negative with a lint-free, soft cloth. After this first application, the coated paper is placed in the sun or near a heat source to aid the absorption of the oil. After a few minutes (overheating will cause the paper to curl), excess oil on the surface is removed with a clean cloth. The reverse side of the paper is then coated in the same way. The oiled negative is stored in an airtight plastic bag overnight. If dry areas are evident the next day, the entire process is repeated until the paper is uniformly transparent.

A paper negative must be free of all greasy residue and should be wiped gently with a paper towel immediately before printing. Paper film is printed image side down in contact with a photosensitive surface. Exposure time for contact printing will need to be lengthened to compensate for the paper's opacity.

You can produce high-contrast paper negatives by printing a high-contrast positive onto high-contrast photo paper. Then coat the negative with oil and allow it to dry before using it to print the final positive photograph.

Color Separations

Photo images that are to be printed in naturalistic color require that color separations be made. A color separation is produced when a color transparency (slide film) is broken down into four separate negatives, one for each primary color—red, blue, and yellow—and one for black.

Color-separated negatives are used in printing processes, such as offset printing, that allow color layers to be printed individually. They are also a prerequisite for full-color photo silkscreen, intaglio, and lithographic printing. Contact-speed sensitizers such as gum, Inkodye, and Kwik-Print, described in Chapter IV, fit into this category. As mentioned before, contact prints are produced from negative film enlargements; for this application, three color-separated film enlargements are required, one for each primary color. Yellow is printed first, next magenta, then cyan, and finally black.

Color separations can be produced professionally. Commercial photo-processing labs are experienced and usually better equipped to make a quality separation than is the individual working in a small darkroom. A professionally produced separation is perhaps the most economical solution when only one or two full-color prints are planned. For those who wish to create their own color separations, however, detailed information on darkroom procedures and necessary equipment can be found in Section 16 of the *Morgan & Morgan Photo Lab Index* or in the Kodak publication, *Basic Color for the Graphic Arts* (Q7).

III

Transfer-Printing Processes

Transfer printing can be defined as a process that allows a photograph or other previously printed image to be transfered onto another surface. A wide variety of transfer-printing processes can be used to obtain very diverse results. Transfers usually result in an image reversal (left becomes right) that can be corrected through a double transfer or through the use of a decal.

Transfer images fall into two major categories: those that use preprinted photos from newspapers, magazines, and so on, and those created from original photographs.

Transfers made from preprinted photos are simple and inexpensive. In addition, they are an excellent source of transfers when darkroom procedures are impractical. The bold color of a magazine advertisement may be captured with an acrylic transfer, whereas a more subtle line reproduction of the image can result from a solvent transfer. The receiving surface is another design variable. A printed photograph from a magazine can be transferred onto fabric, or the same image might be captured in a decal for transfer onto ceramics, glass, plastic, or wood.

Processes for the transfer of original photographic images are generally more complex and thus require darkroom facilities. However, the color photocopy transfer is an exception, since fabric transfer sheets can be printed by a color copier directly from a color photograph or slide.

Original photo images can also be fabricated into photo decals for transfer to three-dimensional surfaces. The image is created on decal paper when ink or paint is silkscreened through a photographic stencil produced from the original photograph. Once the decal has been transferred, it takes on the contours of the receiving surface, and in the case of ceramics, it can be fired for permanence.

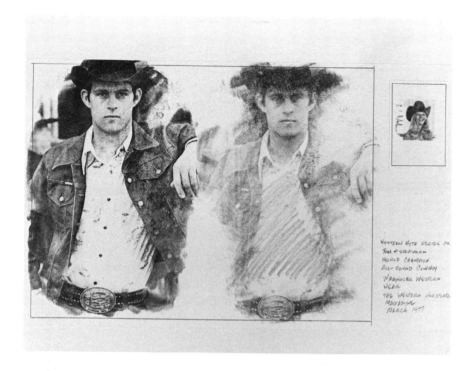

Western Myth Series, #1, a solvent transfer on paper, illustrates the potential of this medium to produce the fine detail of a delicate print. 41″ × 26″. Artist, J. D. Gilford.

Solvent Transfer

Anyone experienced with paint solvents, such as turpentine, has undoubtedly observed their ability to dissolve ink from newsprint, causing the print to transfer to other surfaces. This is the characteristic that makes solvents uniquely suited for the transfer of printed images to a variety of receiving surfaces, such as fabric, paper, and leather. As the solvent's action liquefies the original printing inks, the image can be totally or partially transferred onto another material by the application of pressure to the reverse side of the solvent-coated image. Once transferred, the final image takes on the quality of a rubbing, displaying the delicacy of a pencil drawing that no other means can capture.

All solvent transfers are reversed as a mirror image of the original. Most printed images will withstand this reversal quite well. The exceptions are those that contain lettering, since the lettering would be reversed and therefore unreadable.

Design

A solvent transfer of an image can often inspire a work that develops around a single element. For instance, the image of a face transferred onto fabric might be refined into a portrait with the addition of embroidery, lace, bits of yarn, and colored cloth.

The solvent print produces a subtle, almost diffused image that may lack vitality as an overall design. However, when combined with other imagery—such as a cyanotype contact print—the realistic color and texture of the solvent transfer becomes an important design tool by which portions of the original monochromatic cyanotype image may be emphasized.

Conversely, a textural transfer print on fabric may be used as a background on which a bold photograph is stitched. The two very different textural surfaces would be integrated by the pictorial relationship of the images and their placement in the design.

Materials

The solvent transfer can be applied to almost any material with a reasonably smooth surface that will absorb and hold the transferred inks. Such materials are fabric, leather, paper, and plastic products of smooth polystyrene.

The textural quality of the final print does not necessarily rely on the fabric's texture, but rather on the rubbing technique used to apply the transfer. An even surface, such as a finely woven fabric, is recommended in most cases. You should test transfer acceptance to determine the best receiving surface for a particular type of ink. You can do so by mixing a test transfer of an image found in the same magazine as the one you have chosen for the final process.

Printed materials will also vary in their ability to be dissolved and transferred. Images printed in mass-distribution magazines on poor-quality, thin paper are more easily transferred than those printed on heavier, quality paper with high-gloss inks.

Two types of solvents are available for transfers.* The most common are liquid solvents such as turpentine, lighter fluids, mineral spirits, acetone, and rubber cement thinner. They tend to evaporate quickly, requiring that an image be recoated several times during the process. Liquid solvents also differ greatly in their ability to dissolve printing inks. Finding the appropriate solvent is a process of elimination.

The second type of solvent is a gel used to dilute oil-base silkscreen ink. Oil-base, transparent silkscreen base simplifies the transfer procedure since the oily gel easily penetrates paper to loosen the printed image and evaporates more slowly than liquid solvents. Available at most art supply stores, it is generally more convenient to use than liquid solvents.

Mailable soft postcard embellished with a magazine solvent transfer, rubber stamps, and cyanotype images. (a) Front view, approximately 6″ × 3¾″. (b) Reverse side. Artist, Elaine E. O'Neil.

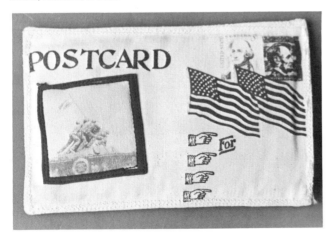

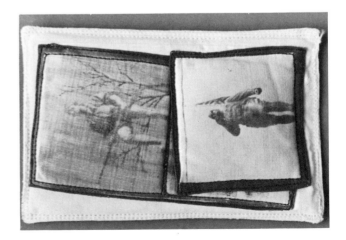

After the ink has been loosened by a solvent, a blunt tool is needed to apply pressure to the paper backing to transfer the image. Which type of tool to use varies with the texture desired. A flat-edged butter knife, a wooden spoon, a clay burnishing tool, or a soft lead pencil are all possible transfer tools; each will give a different result.

Techniques

Only smooth, wrinkle-free surfaces will receive a transfer image properly, so fabric prepared for transfer should be pressed. Materials other than fabric must have a clean, level surface. Before transfer begins, the receiving material should be taped securely to a hard, flat surface.

Once a photo image has been chosen for transfer, it should be trimmed from the printed page with some margin left around it. The size of the margin depends on the size of the transfer area. Small images will require a margin of two or three inches to preserve the paper's strength during hinging and rubbing. You should identify the actual image area to be tranferred on the back of the transfer paper by placing the paper over a lightbox or window and outlining the image area with a pencil. This line will then serve as a guide for rubbing after the image has been placed face down on the receiving material.

When liquid solvents are used, fasten one edge of the printed image to the material with masking tape. Fold the paper away from the receiving material and coat it generously with solvent. Once the liquid has penetrated the paper, making it transparent, fold the paper back over the material and hold it firmly in place. Start rubbing in one area. Lift the edge of the paper periodically to check on the progress of the transfer. If the image dries and fails to transfer, fold the paper back once again and recoat it with solvent. Repeat this procedure until the entire image has been transferred.

This technique varies only slightly when transparent silkscreen base solvent is used. The paper may be hinged to the material with tape in the same way. In this case, however, the image area may require only one coating of solvent. Apply a relatively thin coat of transparent base to the face of the image with a polyfoam brush. After the gel has soaked through to the back of the paper, fold the paper over and press it onto the surface of the receiving material.

The texture of the final transfer depends on the rubbing motion and pressure applied to the back of the solvent-coated paper and on the surface of the receiving material. You can achieve an even-textured transfer by exerting equal pressure over the entire image area. A blunt-edged tool, such as a butter knife, pulled in long, even strokes across the surface of the paper will transfer any image with a minimum of texture.

You can produce uneven textures that resemble shading by stroking the back of the transfer with a smooth, rounded tool, such as a wooden spoon or a ceramic burnishing tool.

* Solvent labels warn of their potential hazards, including contact with eyes and skin. Solvents also produce noxious fumes that are dangerous unless used in properly ventilated areas. Transfer work should be undertaken either outdoors, near an open window, or in an area equipped with an exhaust fan. Most solvents are highly flammable and must be used away from heat, sparks, or an open flame.

To make a solvent transfer: (a) Securely tape the receiving material and transfer to a flat surface. (b) Generously coat the image with solvent. (c) Use a blunt-edged tool such as a butter knife to transfer the dissolved ink onto the fabric. (d) Using even pressure, stroke the back of the image with the tool to transfer the solvent print.

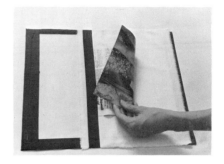

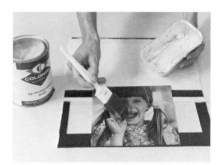

A soft lead pencil is unmatched for producing fine details in the transferred image. Pencil strokes may be applied many ways, depending in part on personal interpretation of the image. However, this rubbing technique will be most successful when it visually enhances the transferred images without creating a chaos of lines. You can create patterns within the image by applying straight, curved, or scribbled lines to the paper backing to give the impression of a pencil sketch. Simple images that are systematically developed through the motion of the pencil burnishing are the most visually effective.

Tally Ho. A solvent transfer was used as background imagery to dramatize the central photographic print. 10″ × 14″. Artist, Richard B. Hubbard.

Gail-Faces. Mixed-media fabric design created around multiple Xerox solvent transfer images on muslin. 70″ × 54″. Artist, Ann Gati.

SOLVENT TRANSFERS FROM ORIGINAL PHOTOGRAPHS

The solvent transfer technique, used in conjunction with an electrostatic copy machine print (black-and-white or color), is an excellent method for reproducing an original photo on fabric and other porous surfaces.

Black-and-white photos with strong contrast and good line definition can be easily transferred after an electrostatic copy has been made. The entire copy, a section of it, or several photos can be transferred. The copy of a photo is placed face down on a smooth fabric or other receiving surface. With the copy in place, a small area of the paper backing is saturated with solvent (acetone or lacquer thinner). This area is rubbed with a stiff cloth such as raw canvas until the ink has transferred onto the receiving surface. Several applications of solvent may be necessary to achieve a total transfer. If the ink fails to transfer, the fault usually lies with the photocopy. A number of experimental copies should be printed on different types of copy machines until a transferable copy is produced.

Color electrostatic copies made from an original color photograph or a slide transparency can be transferred through the use of transparent silk-screen base and the techniques described for the transfer of preprinted images. The full-color print is coated with a thin layer of solvent, placed over the receiving surface that is lying on a flat, padded surface, then rubbed until the image is transferred. Color transfers made on washed, unsized fabric are durable and do not greatly alter the cloth's texture.

A number of transfer techniques, including an acrylic transfer, were combined into a collage of magazine and newspaper images on illustration board. 20″ × 15″. Artist, Pat Fosnaught.

left: To create *Cat Collage*, the artist combined several images and then transferred them onto the fabric. After portions of the collaged images were stuffed and stitched, the fabric was stretched over a frame. Artist, Cathy Westfall, grade 11. Art teacher, Joan Tallan, Alternative High School, Dayton, Ohio.

right: Soft sculpture hanging consists of multiple acrylic transfers, each stitched, stuffed, and attached to the background containing the primary transfer image. Artist, Brenda Hocker, grade 12. Art teacher, Joan Tallan, Alternative High School, Dayton, Ohio.

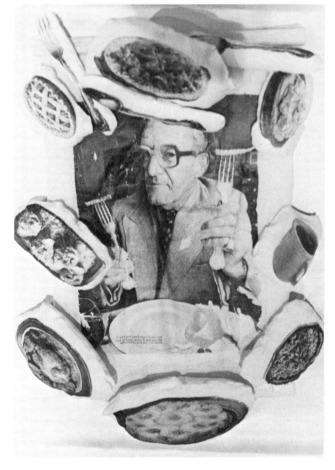

Acrylic Transfer

The acrylic transfer is perhaps the simplest, most versatile method of transferring a printed image from one surface to another. Acrylic or polymer media adhere to printed surfaces to lift images from their original paper supports. The image contained in the clear medium can then be transferred onto any secondary surface that will accept and hold the acrylics. These secondary surfaces include fabric, acetate, paper, wood, glass, and ceramics.

Techniques for acrylic transfer vary only slightly, depending on the receiving material. A direct transfer of an image will produce an image reversal, while the two-step decal process will not.

Design

The search for "found images" for an acrylic transfer is the first step in the design process. Images from almost all magazines and newspapers are eligible for transfer; however, occasionally an image or type from the back of a thin page will show through. "Slick" color images printed on clay-base paper which has a smooth, coated appearance or feel, are the most reliable for decal techniques.

Finding a single magazine image that is meaningful in its own right is rare. Usually the design idea will emerge from a combination of images and materials. An acrylic transfer might be the focal point of a design or merely a single element in the total composition. Whatever the design problem, the transfer should never appear as an afterthought. In a well-integrated piece, the acrylic transfers relate well to the color, texture, and shape of the material to which they are applied.

Acrylic transfers made on fabric are particularly appealing from a design standpoint. The image adhered to fabric can be manipulated into a variety of shapes. Fabric can become a canvas on which single or collaged images are transferred to "paint" the two-dimensional surface. Stitchery, printed fabric, yarn, or padding might be added to accentuate areas of the design.

In other examples, the image itself suggests a three-dimensional form. The transferred image may then be transformed into a stitched and stuffed creation that evolves from the image outline. Several stitched and stuffed individual shapes may be grouped as a floor sculpture or attached to a canvas background and hung individually in a series.

Pliable acrylic decals can be adhered to a variety of three-dimensional surfaces. Typical of these decals are full-color images from "slick" magazines that are transferred onto ceramics, glass, or wood. With this type of transfer, the decal can be applied only after the clay has been glazed and fired or the wood finished. This method represents a different design sequence than that encountered in direct transfers, and it demands careful planning to achieve a final transfer that succeeds both visually and conceptually.

Clear, flexible acetate on which full-color images have been transferred can be used to create interesting effects. A sheet of acetate might be conceived as a window on which a foreground image is applied. This image on acetate can then be placed over a background of textural material or

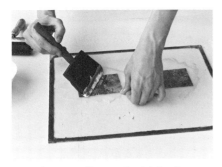

To make an acrylic transfer: (a) Apply a heavy coating of polymer gel to the image surface.

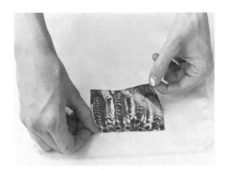

(b) Place the coated image face down on the fabric.

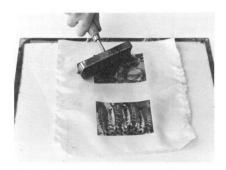

(c) Roll with a brayer to ensure wrinkle-free adhesion.

(d) If necessary, recoat poorly adhered corners.

related images to create the illusion of depth. Another illusion can be devised by using several sheets of acetate, each with one or more images, hung at close intervals for a graduated sequence simulating movement in space. Acetate transfers can be stitched and stuffed with textural material, or heat-sealed and inflated with air. The quality of the image will often suggest a direction for the work.

ACRYLIC TRANSFERS ON FABRICS

Materials

A printed image from a magazine is best for this type of transfer. Either black-and-white or color images can be used, depending on the design application. The variety of images available is almost limitless.

When you choose a fabric for an acrylic transfer, note that the printed image, along with a thin layer of acrylic, will be deposited on the fabric's surface. The texture of the fabric receiving the image will be altered slightly because of the consistency of the acrylic gel or "skin." Fortunately, acrylic gel does remain pliable, so that transfers on most fabric can be stitched or hung without distortion. The exception might be a sheer fabric that becomes weighted down with acrylic deposit.

Generally, medium-weight, fine-textured fabrics of pure cotton or blends are best suited for acrylic transfers. Conversely, knitted fabrics and those of 100-percent polyester fibers will not absorb the transfer materials properly and should be avoided.

A polyfoam or fine-bristled brush is needed to apply the acrylic polymer emulsion to the face of the image. A brayer, soft cloth, blotter, and a tray with warm water are also necessary.

Techniques

Place clean, pressed fabric on a flat, seamless worktable or drawing board. Trim away all areas of the image except those to be transferred. When a collaged image is to be transferred in one piece, you must assemble the collage pieces sequentially, with the last image on top, and then glue them with white household glue. Place the dry completed collage or individual image cutouts face up on a sheet of glass and brush them with a heavy coating of acrylic gel, applied evenly over the entire collage. The image will become barely visible under the milky coating. Twenty or thirty seconds after the coating, the paper will curl, signifying that the gel has soaked through the surface.

Place the coated image face down on the fabric and position it carefully. Roll a brayer over the image several times to press the layers tightly together and to eliminate all wrinkles or air space that might prevent a total bond. Check the edges of the transfer to see if they have adhered. When a portion of the paper does not adhere, lift and recoat it with a thin layer of gel and roll over it with the brayer. After the entire transfer firmly adheres, reverse the fabric (paper side down) and roll the brayer on the opposite side.

The paper backing can be removed from the fabric only after the acrylic gel is totally dry. (Overnight drying is essential for most fabrics.) After drying, the fabric is placed in a pan of warm water, paper side down. The

transfer area is soaked in warm water for several minutes until the paper backing appears to have softened and can be peeled away easily with the fingers. If any section of the image threatens to peel from the fabric along with the paper backing, the entire peice should be resubmerged in water, and peeling should begin at the center of the transfer to prevent damage to the edges. After the backing has been totally removed, loose areas of the transfer can be reglued after the fabric is dry. You can accomplish this by brushing the area with gel and pressing it to the fabric until a smooth bond is formed.

Once the fabric is taken from the water, the fabric should be laid, image side up, on a blotter to remove the excess moisture and paper fibers. The image area can be gently wiped with a damp cloth to remove any white flecks caused by paper fibers that remain enbedded in the acrylic "skin."

The fabric is then hung to dry overnight. After drying, the image may be brightened with a very thin coating of gel applied to the transfer area only.

ACRYLIC TRANSFERS ON ACETATE

The acetate transfer, or lift, has a variety of uses in addition to those used for direct design application. A black-and-white magazine or newspaper image, transferred onto clear acetate, can become a film positive for several direct printing processes that require a positive film image. A magazine photograph printed in halftone dots is especially well suited for an acetate transfer that can be used as film for silkscreen printing. The transfer is placed over a light-sensitive emulsion used to coat a silkscreen, and the image is contact-printed directly on the screen to create a printing stencil. This procedure is more fully explained in Chapter V.

Materials

Material requirements are the same as those for the fabric transfer, except clear acetate or Mylar replaces the fabric support.

Techniques

The image chosen for transfer is cut out and placed face up on a dry, clean surface that has been covered with plain paper. When several images are

(e) After rolling it with the brayer, lay aside the fabric to dry.

(f) After the polymer is totally dry, soak the fabric in water.

(g) Peel away the paper backing leaving only the polymer adhered image.

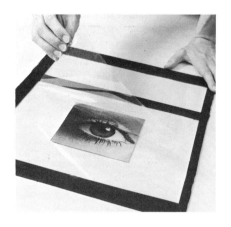
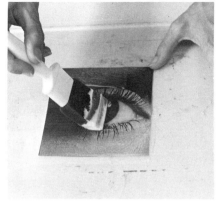
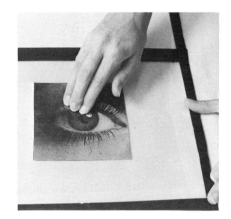
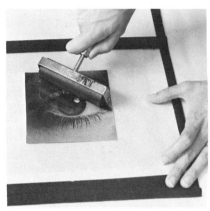
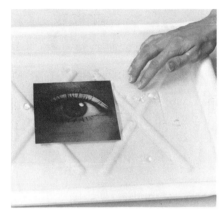
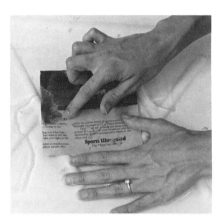
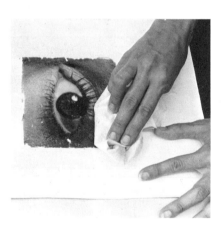

To make an acetate transfer: (a) Position the image under a hinged piece of acetate. (b) Remove it and coat it with polymer. (c) Once the transfer has returned to its original position, smooth the acetate over the image. (d) Use a brayer to remove all wrinkles. (e) Once the acetate is dry, place it in water until the paper backing is soft. (f) Peel away the wet paper. (g) Carefully wipe the transfer image; it is ready for use when dry.

to be used in the form of a collage, they should be glued together with white housegold glue and allowed to dry overnight.

A clean, lint-free sheet of acetate is laid over the image or images and taped to the working surface at one edge to provide a hinge. The acetate can then be lifted and the images positioned until a satisfactory layout is achieved. The image position is then outlined on the underlying paper. Next, the printed image is removed from the paper, placed face up on a sheet of glass, and evenly coated with acrylic gel. It is then returned to its original position on the paper. The hinged acetate is lowered over the coated surface, with the transfer now in place; the acetate-paper combination is reversed so that the paper backing can be smoothed with a rubber brayer. During this procedure, any excess gel that might seep from the edges of the paper must be wiped from the acetate immediately with a damp cloth.

The acetate-paper combination is then laid on a flat surface, paper side up, and dried overnight. When totally dry, the original milky color of the gel will have become totally transparent, indicating that the paper backing can be removed without damage to the acrylic transfer adhered to the acetate.

The acetate sheet is placed paper side down in a tray of warm water large enough to hold the acetate without folding or wrinkling it. It is soaked for several minutes until the paper backing becomes soft. It is then

reversed, and the paper backing gently rubbed from the acrylic "skin" while it remains submerged in the water. Once the paper fibers are removed, the adhered image should appear translucent through the surface of the clear acetate.

ACRYLIC DECALS

Decalcomania is a form of transfer that normally depends on a temporary transfer or decal sheet. The decal paper holds the printed image, supporting it until it can be transferred onto the final receiving surface.

In a similar way, clay-base papers that hold printed magazine images act as an intermediate support from which the image, coated with polymer gel, can be transferred. Images suspended on an acrylic "skin" can be removed from their paper backing and applied to any surface that will bond with an acrylic medium.

Using this exceptionally simple technique, decals for many types of applications are readily available from the printed pages of almost any magazine. Acrylic decals are flexible owing to their plastic base. However, they cannot be totally waterproofed and cannot withstand rough wear or long submersion in water, as can a fired ceramic decal. Nevertheless, acrylic decals are inexpensive and easy to prepare, and they will adhere to a variety of surfaces with a reasonable degree of permanence.

left: Although acrylic decals cannot be fired, they may be adhered to ceramics with interesting results. The printed photograph of an Eskimo mask was applied to a ceramic pitcher whose configuration relates well to the decal.

right: Acrylic decals can be applied to most fabrics, including knitted tee shirts. Artist, Rammy Hinton, grade 10. Art teacher, Pat Fosnaught, Trotwood-Madison High School, Trotwood, Ohio.

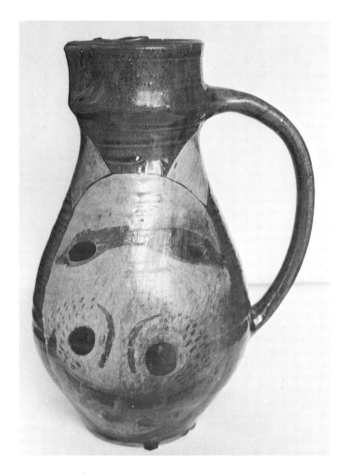

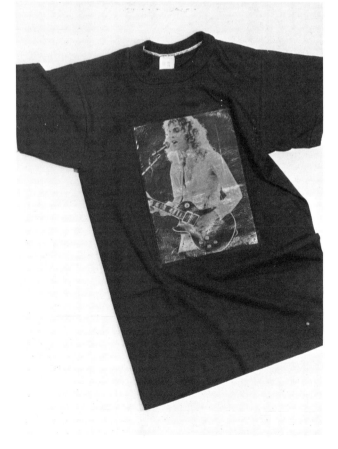

Design

Often the acrylic decal itself will provide the inspiration for the shape and perhaps even the material to be used. Whether a piece is designed in conjunction with a specific decal or a decal is to be applied to an existing work, decal placement is an important aesthetic decision.

A single decal can become a focal point of a work only when the receiving material helps dramatize the photographic image. For example, the flat photograph of a primitive mask takes on greater meaning when applied to a rounded ceramic shape that suggests the mask's dimensional character.

An alternative is to apply several decals to a receiving surface. The photo images can be grouped to indicate a visual relationship, or cut and collaged (with edges touching but not overlapping) to create new imagery. Series of small decals can be applied in an overall pattern, to create a changing rhythm over the surface of the work.

The texture, color, and shape of the materials are important to the overall continuity of the decal and the receiving material. The glossy surface of the acrylic decal can be modified slightly, but its textural quality will profoundly affect the surface to which it is applied. A glazed ceramic surface can camouflage the fact that the decal was an addition, while a decal adhered to a knitted shirt calls attention to its texture as well as its imagery.

The acrylic decal is adaptable in that it can be adhered to a variety of surfaces that will not accept a direct acrylic transfer. Another important advantage is that the acrylic decal, applied face up, does not reverse the image and allows preprinted photo images that contain lettering to be incorporated into the design.

Materials

Acrylic decals can be adhered to the three-dimensional surfaces of ceramics, glass, Plexiglas, polyurethane-coated wood, or any surface on which acrylic medium is coated. Knitted cotton and polyester fabrics can also be used.

Good-quality images printed on clay-base paper (slick finish) are best for decal work.

A polyfoam or fine-bristled brush is needed to coat the face of the image with acrylic polymer gel or medium. A tray of tepid water is used to remove the decal from its paper backing.

To apply an acrylic decal: (a) Coat the printed image with polymer and allow it to dry. Repeat this procedure five to eight times. (b) After the multiple coatings have dried overnight, soak the decal in water. (c) Then peel away the paper backing, leaving only the acrylic skin impregnated with the image.

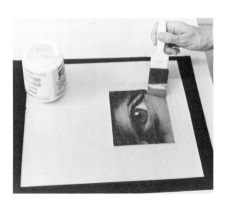
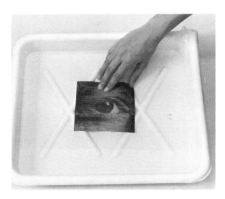
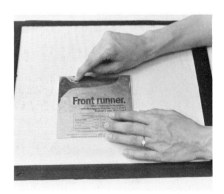

The artist printed this color photogram by placing fabric and a peacock feather on color photo paper and exposing it to light. 8″ × 10″. Artist, Masumi Keesey.

The color Xerox print *Triptych #2: Madame Lorraine and the Peacock Feathers* combines photo images and actual materials. 8½″ × 14″. Artist, Jill Lynne.

The photo-collage *Main Street, 1975,* was created from magazine images mounted on a foil background colored with India ink. 36″ × 24″. Artist, Mick Wooten.

Assemblage with glove contains a cyanotype image printed on polymer. 6″ × 8″. Artist, Diana Barrie.

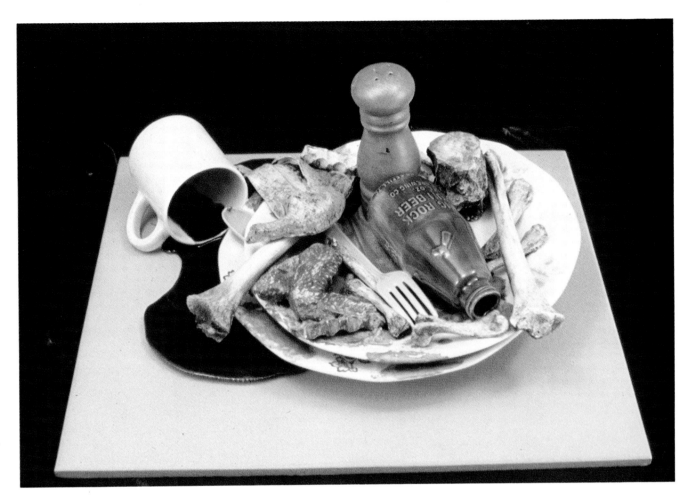

Plate with Bones is an actual-size ceramic sculpture with photo decals. Artist, Victor D. Spinski.

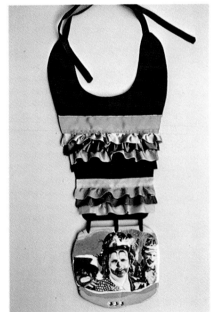

New York Clowns combines a soft neckpiece with a ceramic shape containing a photo decal. 5½″ × 12″. Artist, Karen Godeke.

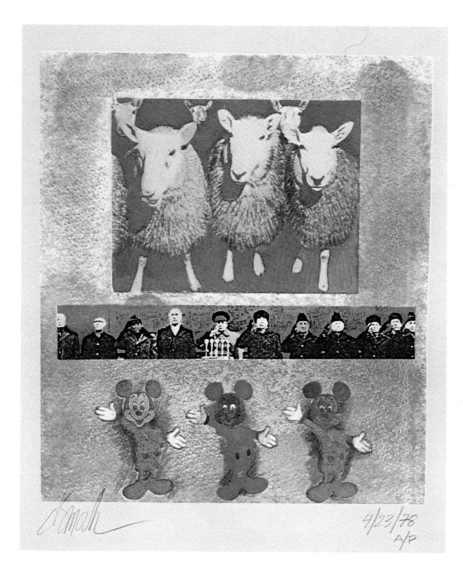

Burning Nails, a Xerox solvent transfer print with hand coloring, is the introductory print in a suite of twenty-four. 11″ × 15″. Artist, J. Thomas Nelson and Doug Smock.

Tossed Salad is a stitched and stuffed soft sculpture created from photo silkscreen images printed on fabric. 12″ × 17″. Artist, Lou Brown DiGiulio.

The photo sculpture *Perpetual Care Cabinet* was constructed from formica, wood, mirrors, fabric, laminated photos, and hardware. 66″ × 29″ × 6″ open. Artist, Richard Newman.

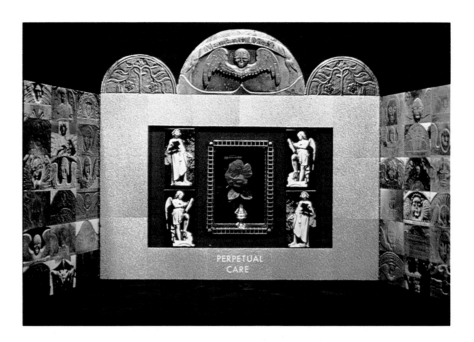

Selected sections of the Vandyke print *Fruit Stand* were hand-colored. The print on cotton fabric is stitched to a linen background. 11″ × 14″. Artist, Mary Stieglitz.

Banana Table, 1978 is a composite image produced when selected areas of fifteen frames of SX-70 photos were transferred onto transparent plastic. 9″ × 12″. Artist, Ardine Nelson.

A life-sized mural created on seventy separate ceramic tiles is composed of multiple photos taken in a grid pattern and then printed as a composite figure. Color was applied with china paint overglazes. Approximately 22½″ × 63″. Artist, Robert Shay.

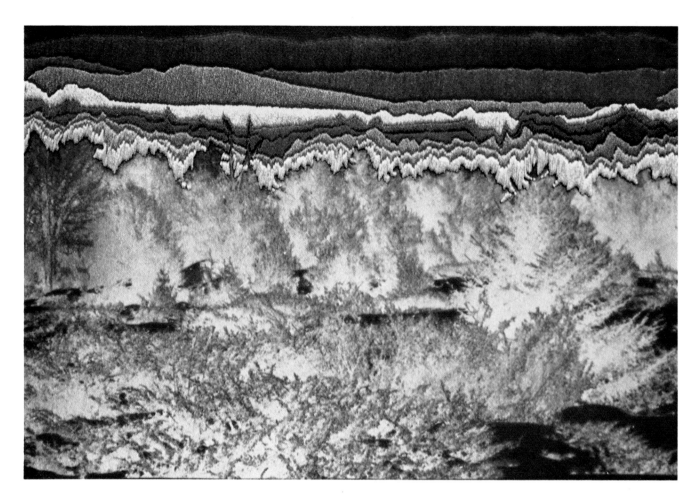

Landscape I, a negative image cyanotype printed by the Pellet process, is colored with embroidery. 14″ × 11″. Artist, Judith M. Stauffer.

Techniques

The images chosen for decals are laid face up on a sheet of glass and given a thin, even coating of acrylic polymer gel. The brush used for coating should be slightly damp to aid in even application. After the first coating dries for twenty to thirty minutes, the second coat is brushed onto the surface of the image in the opposite direction to the first. This process of coating and drying is repeated until the image has received five to eight coatings of gel. Once the final coating is complete, the images are allowed to dry overnight until the gel becomes totally transparent and slick to the touch.

Once the gel is dry, the image is soaked, paper side down, in a tray of tepid water for ten minutes or so. When the paper becomes soft, it can be removed by rubbing with the fingers until the backing peels away from the acrylic "skin." The fragile, water-soaked decal must be handled gently during this procedure. After all paper fibers have been removed, the image will appear semitransparent and must be thoroughly dried to produce a clear decal base. The wet decal is laid flat on a clean blotter and gently wiped with a paper towel to remove the excess water. After drying overnight, the decal is ready for use.

The receiving surface must be dry and clean of fingerprints, dust, or any material that might prevent adhesion. When the decal is to be adhered to a flat surface, the only requirement is that the area to receive the decal has a thin, even coat of acrylic gel. The decal can then be applied directly with image face up and smoothed on with the fingers. Any excess gel should be wiped from the decal with a moist cloth. After the decal has dried for several hours, a final coating of gel is applied to the decal surface to blend and seal it into the surrounding area.

The pliable quality of these decals enable them to take on the contour of a variety of receiving surfaces. When a curved or otherwise irregular surface is to be used, the decal is heated with a hair dryer until it is pliable enough to be manipulated into a contour matching that of the receiving surface. The area to receive the decal is coated with gel and the decal applied and held in place for several minutes until a bond has formed. Excess gel is wiped from the decal, and the decal is dried for several hours before a final sealing coat of gel is applied over the entire area.

Decals to be adhered to a three-dimensional surface are heated until flexible. (a) A hair dryer can be used to heat acrylic decals. (b) Once warm, they take on the configuration of the receiving surface more readily. (c) The receiving surface is then coated with gel and the decal applied immediately. (d) After drying, a thin coating of gel is painted over the surface of the decal.

Photographic Decals

As the name implies, a photographic decal is a product of a photographic process (photo silkscreen). It is produced from an original black-and-white or color film image, and can be fabricated with specially formulated inks and varnishes to suit almost any receiving surface. It differs greatly from an acrylic decal which is created from a preprinted image.

To begin, a photo silkscreen image is printed onto a decal paper. Decal images may then be transferred onto irregular surfaces that are impossible to print by any other means. For example, you can produce a ceramic decal by silkscreening a low fire glaze onto decal paper. Using this method, you can fire a ceramic piece embellished with an image as permanent as the material to which it is adhered. Photo decals are versatile in that they can be printed with different kinds of inks, making them stable enough to be adhered to glass, metal, plastic, and wood surfaces. Photo decals are one of the most successful and permanent means available for transferring original photographic images onto three-dimensional surfaces. However, the production of a photo decal is a complex process that requires both darkroom facilities to create the photo silkscreen stencil and the purchase of several specialized materials. To invest a great deal of time and money into the manufacture of a few decals is impractical. Unless a large number of decals are needed over a period of years, the best solution is to have decals custom-fabricated. Commercial silkscreen printers often handle decal inks and papers and can custom-print decals that can be easily water-mounted to metal, glass, or almost any hard surface. Ceramic decals are somewhat more specialized. Ceramic suppliers usually do not offer this service, but they may be able to suggest a local decal producer. If not, custom-made photo decals can be mail ordered from a ceramic decal fabricator.

Ceramic decals can be applied to ceramic, china, or porcelain ware and fired slowly at the specified firing temperature. For example, suggested firing temperature for a ceramic piece containing a decal is cone 018 or 017, whereas cone 017 or 016 is suggested for firing china and porcelain. Decals cannot be fired over another overglaze material such as china paint or luster. When color is to be added to a decal in the form of a luster, it must be added after the decal has been fired and will therefore require another low-temperature firing.

Design

Design problems presented by photographic decals are similar to those involved with acrylic decals. You should carefully plan both the decal and the piece that is to be embellished to ensure that the design will be well integrated.

Two primary considerations are involved in choosing and preparing a photo image for decal design: (1) the interest of the image as a visual statement, and (2) the relevance of the image to the structure and design of the piece. You may need to evaluate numerous design approaches before you come up with a satisfactory composition.

A single decal image that is to be the focal point of a design demands thoughtful placement for full impact. The work's color, shape, and texture should accommodate the image. A plain background may provide an ap-

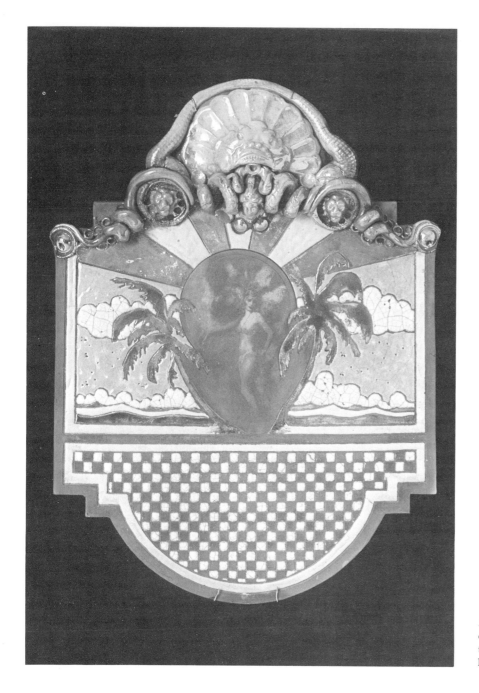

An elaborate ceramic environment was created to further enhance the fantasy of the photographic decal. 19″ × 19″. Artist, Marc Sijan.

propriate setting for an intricately detailed image, whereas a more complex environment may be needed to develop the illusion present in a single image.

Whenever several decals are incorporated into a single work, their relationship must be visually clarified. Decals may be grouped to produce the fundamental drama of a piece. The surrounding structure of the work then becomes the framework in which the images are viewed.

An alternative to single or grouped placement is an overall surface pat-

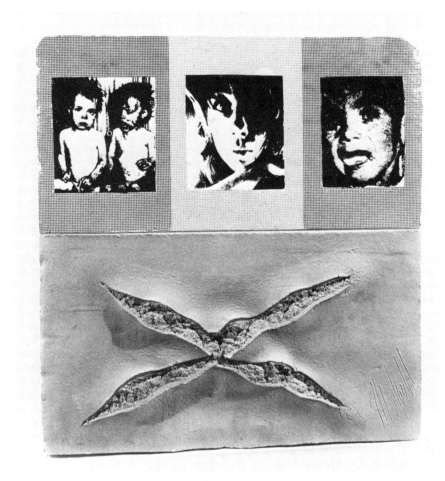

The stark imagery of three photo decals is dramatized by their placement in this design. 22" × 24". Artist, Allan Maxwell.

tern comprised of several identical or related decals. Their placement and spacing will depend on the three-dimensional form that they are to adorn. When a single image is repeated around the circumference of a cylinder, the separate images give way to a unified pattern that flows over the surface. Alternating colors or pattern groupings will emphasize individual elements within this pattern.

Materials

A materials list will vary according to the type of decal and the transfer method used. Reference sources that give instructions for making decals for ceramic and other surfaces are listed at the end of the book. However, some knowledge of the function of decal papers is valuable even when the decals are to be created commercially.

Simplex paper is a slide-off watermount decal paper coated with a water-soluble film that carries the image. Because of the paper's composition, printed decals slide off its surface and onto the receiving material without image reversal. Decals for most types of applications, including ceramic decals that can withstand kiln firing, are printed on simplex paper. Materials needed to affix this decal are available in every household.

Duplex, or double-transfer, paper is applied to hard surface materials when you will not kiln fire. This type of paper is ideal for those rare occasions when decals are adhered to a sculptural piece intended for exhibit outdoors. Duplex paper consists of two layers: a tissue that carries the design and a heavy backing sheet.

Techniques

To mount the duplex decal, you simply peel away the protective tissue and adhere the decal to the receiving surface with a coating of varnish.

To mount the simplex decal, you must first trim around the image to remove any excess paper. When you want to adhere the decal to an irregular surface, you can pretest its placement by cutting a paper pattern the same size as the decal and lay it over the area in question. After trimming the decal, place it in a tray of tepid water, image side up, and soak it for twenty to thirty seconds or until the paper curls. Remove the decal from the water and place it on a paper towel for several seconds until it flattens. Meanwhile, moisten the receiving surface. Then, with the backing paper still in position, place the damp decal face up on the pre-moistened surface. While the decal is held in place, carefully slide the paper backing out from under the decal, leaving only the decal adhered to the receiving surface. Once the decal is in place, you must remove all air bubbles and moisture to ensure that the adhesive incorporated in the decal backing makes a tight bond with the new surface. To do this, blot the decal with a soft cloth or facial tissue, then smooth it from the center outward using your fingers or decal squeegee. Finally, wipe the entire transfer area with a moist cloth and allow the decal to dry overnight. Once thoroughly dry, the decal transfer is complete, with the exception of ceramic decals, which have to be fired.

When several related decals are to be adhered to a surface to form a pattern or spliced to form a new image, the decal images must be precisely placed and fitted for smooth adhesion. Decals cannot be overlapped, particularly not ceramic decals. Overlapping of ceramic decals will cause burn-out in these areas during firing. To fit one image against another, portions of the first decal must be cut away with an X-Acto knife before they become dry. The second decal image is then fitted and adhered in the provided space.

(a) *Shake, Rattle and . . .* , a ceramic sculpture with accompanying satin zipper pouch, employs an overall pattern of decal images, with two rows of images emphasized with lines. 13" wide. Artist, Allan Maxwell. (b) Reverse side.

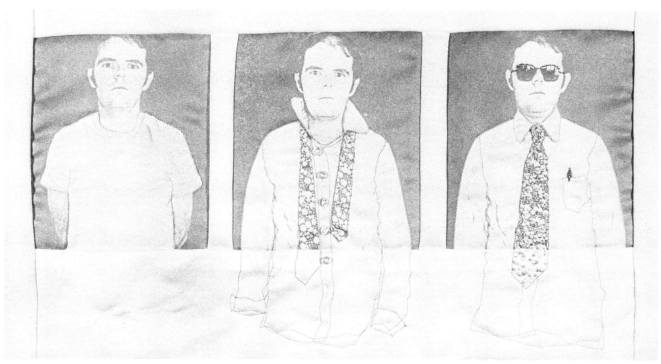

(a) A 3M color dye transfer was used to produce the soft *Comic Strip* on polyester fabric. 18½" × 10". (b) Close-up shows how stitchery was used to dramatize detail. Artist, Nancy Hynes.

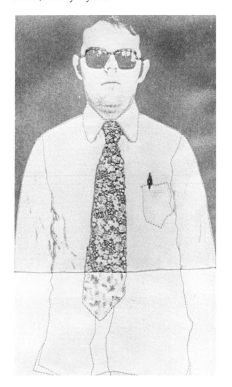

Thermal Transfer

SUBLISTATIC DYE TRANSFER

Thermal transfer is the new technology of the fabric printing industry. With this relatively easy and inexpensive process, highly detailed full-color patterns are printed on millions of yards of fabrics each year.

In this two-step process, a preprinted dye paper is placed in face-to-face contact with a polyester fabric. Once subjected to heat under pressure, the dye "sublimes," or vaporizes from the paper, then cools and condenses on the fabric, bonding permanently to the fibers.

Even if you do not have the equipment to print millions of yards of fabric, you can adapt this method to the transfer of individual designs, including photographic images.

A disperse dye paper for transfer can be used in conjunction with a black-and-white electrostatic copy of a design or photograph. First you must place the dye-impregnated transfer paper in a heat press with the electrostatic copy. In this manner, the color is transferred onto the dark portions of the electrostatic print to produce a dye-transfer image. You can then affix this image to the fabric by use of a heat press or hot iron.

Design

The size of the dye sheets and the photostatic copies will limit the size of the area to be printed. The production of an overall fabric pattern for printed yardage is not feasible because of size limitations. Sublistatic transfer is best suited to the design of individual images that are collaged, overlapped, or placed in patterns over the fabric surface.

Color in design is controlled by the original dye sheet. Commercially printed sheets offer a somewhat limited color selection. However, two preprinted color sheets can be combined by heat transfer to produce a third color. Or, for even greater color control, you can make dye sheets by screening special inks onto hard-surface paper.

Good contrast and sharp details are necessary when copying an original photograph for transfer. Several different images may be copied before a strong print suitable for fabric transfer is found. Preplanning is always necessary for the economical use of dye sheets. Several small images can be photocopied at one time, creating one photostatic print. This print is placed in the heat press with one dye sheet and later cut apart before the final transfer to fabric.

If original photographs are not available, preprinted magazine images will also reproduce well, particularly strong black-and-white magazine photographs. As mentioned, these images may be collaged or copied as separate elements onto one sheet.

Materials

Commercially printed "dye-transfer paper" is available in plain colors as well as preprinted patterns. You can produce hand-printed dye sheets by silkscreening Transcello Ink onto hard-surface paper.

For the most predictable results, the photostatic copy would be made on a black-and-white copier (IBM II works well). The fabric must be 100-percent polyester, preferably a fine weave or knit.

The heat transfer process works best when heat and pressure are controlled by means of a heat press or dry-mount press. An iron (350°F to 400°F) may be substituted when small design elements are transferred.

Techniques

After the photo image has been electrostatically copied, the first transfer may take place. The copy is laid in face-to-face contact with the dye transfer sheet, dye sheet on top. The sheets are then placed in a protective folder of plain paper to prevent ink damage to the press. The sandwich of paper is heated at 350°F for fifteen to thirty seconds. The sheets are removed, and the paper peeled apart to reveal the color of the dye sheet deposited on the printed areas of the photostatic copy. The dye sheet, with color removed, appears as a negative; it might also be used for fabric transfer when positive/negative images are desired.

The same procedure is used for the final transfer of the color image to the fabric. The dye copy is placed face down on the fabric and inserted into the heat press, with the dye sheet on top and covered with plain paper. After fifteen to thirty seconds at steady heat (350°F), the fabric is removed and the transfer is peeled away. The monochromatic color image is now permanently bonded to the fabric. This process may be repeated with overlapping colors and images transferred over the original to create a multicolored image without damage to the dye.

ELECTROSTATIC COLOR TRANSFER

Color copying machines are one of the practical marvels of our age. They can produce full-color prints from an original color photograph, a color

slide, or the actual three-dimensional material. By means of an electrostatic process, three primary toners—cyan, magenta, and yellow—are combined to create a total of seven colors, including the process black. When a color separation is desired, the original can be printed in any of the three primaries—a procedure that was previously time-consuming and complex. In the view of the textile artist, however, the color copier's most valued asset is its ability to print full-color transfer sheets. These sheets may then be permanently bonded onto fabric using melt transfer, which is a special process within the general category of thermal transfer.

Design

Before you use a machine to produce color photocopies, it is necessary to overcome the preconception that a copier's single function is to produce a facsimile of an original image. Machine-printed color, although it does duplicate color realistically, has its own distinctive quality. Added to this is the fascination of color manipulation. For example, you can make a two-color print from a black-and-white original by removing the subject from the copy glass at a critical moment during the screening process.

A color photograph can be copied directly onto specially coated transfer paper. The color of the original will reproduce with good fidelity, but a copy of a single photo may lack the vitality of a composite image.

A more inventive approach might be to begin with a black-and-white photograph. The machine's color selector buttons enable color to be printed arbitrarily. A black-and-white original can be printed as a yellow-and-white image when the yellow color selector button is pressed before printing. This is true of the three primary colors—yellow, cyan, and magenta—plus combinations of these three. For instance, by pressing

Soft Jewels. Color photograph of a diamond necklace printed on a transfer sheet via a color copier and transferred onto satin. Artist, the author.

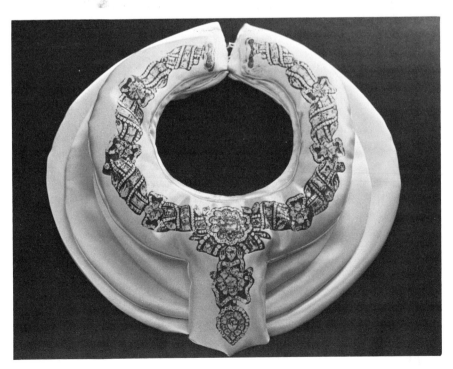

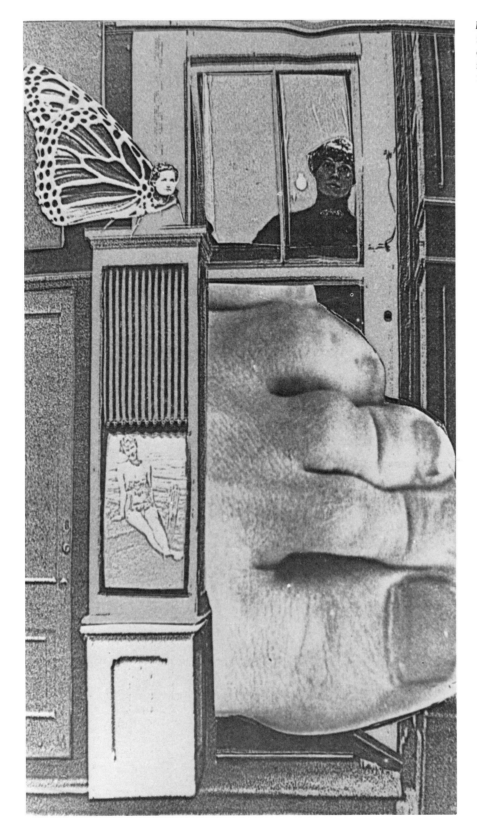

Dreams, #7. One image from a series of fifteen color Xerox transfers on satin created from collaged color copies printed from black-and-white photographs. 14″ × 18″ × 6″ each. Artist, the author.

both the magenta and yellow buttons, red is produced; by combining cyan and yellow, green is printed. Using this technique, all colors desired can be printed from the original black-and-white photo. The single-color copies can then be cut and collaged to produce a multicolor composite. After assembly, this composite becomes the original and is placed on the copy screen to be printed in "full color." When the color original is skillfully composed, the final print shows no visible cut lines or obvious signs of manipulation.

Hand-colored black-and-white photographs can also be used to print full-color transfers. A photo enlargement or a composite of several photos can be colored with acrylic paint, photo dyes, or waterproof marking pens. Color can be applied to simulate the texture of a pen-and-ink drawing, the wash of a watercolor, or the density of an acrylic painting, according to the effect wanted.

The 6500 Xerox Copier will print directly from 35mm slide transparencies in slide mounts. This capability allows you to print a favorite color photograph and then transfer it directly onto fabric.

All slides will reproduce, but those with good color balance, detail, and crispness will succeed best in machine-printed form. The slide chosen for printing is first placed in a regular slide projector that projects the image through a specially designed lens supplied with the color copier. After the slide image has been focused within the appropriate paper mask placed over the copy screen, the final full-color print ($9\frac{1}{2}'' \times 6\frac{1}{4}''$) can be made with a simple push of the print button.

One of the most interesting and unusual aspects of "machine" art is the print produced from a textural or three-dimensional object. The machine "sees" and prints the color of actual objects very distinctively, lending a pictorial quality to the reproduction process that is not possible by any other means. Textural objects of all types—nubby yarns, fabric, old lace, leathers, plants, flowers, the human hand, or anything that can be placed on the machine's copy glass without damage—will reproduce successfully. The texture of stitched fabric can be further dramatized when combined with a photographic image. Collages containing textural materials as well as magazine images provide the elements for a design that can be further enhanced by transfer onto colored fabric.

(a) Hand-colored photographs were printed and transferred onto fabric to be incorporated in the mixed-media composition, *American Metamorphosis.* 48″ × 48″. Artist, John Fordyce. (b) Detail.

Materials

The Machine

Color copiers (the 6500 Xerox Copier is most widely available) can be found in instant-print shops in most large and medium-sized cities. The nearest Xerox office will have a directory of machines available for use in each area of the country. Printing shops are in the business of selling copies, and prices per copy will vary with the supplier and with the procedures involved. The shop will charge extra for running a print on transfer paper when you do not provide the paper. Because of the expense of the toner and the investment in a very complex machine, per-copy charges add up quickly, making experimentation costly. It is advisable to use one design that can be perfected for a final transfer. As many as three or four paper runs may be necessary before the desired effect is obtained.

The Transfer Paper

Transfer paper, developed for use in the Xerox 6500 Color Copier can be purchased in bulk amounts (100 sheets or more). The newest and most permanent type of transfer paper is coated with a thermoplastic binder, whereas the conventional type of transfer paper is coated with silicone to provide a slick surface from which the printed image may be transferred. When subjected to heat and pressure, the entire matrix (binder impregnated with toner) of the thermoplastic sheet is transferred to the receiving surface. The plastic-sealed, full-color image resulting from this type of transfer changes the texture of the fabric only slightly, yet it is more permanent and distinctive in quality than a conventional transferred image.

The single transfer, however, is sometimes unsatisfactory—particularly for printing photos that contain lettering—because of the image reversal. Therefore, the Trans Reversal sheet is an important product for transfer printing, since it supplies a method for double transfer. First, the Trans Reversal paper is printed on a color copier. The printed sheet is then placed in contact with a sheet of single transfer paper (either thermoplastic or regular) and bonded in a dry-mount press for half a minute. After the two sheets are separated, the printed image appears in reverse on the second sheet and may then be transferred onto the fabric in the usual way. Trans Reversal sheets can be purchased individually and are reusable.

The Fabric

Fabrics recommended for transfer by the manufacturer of the transfer sheets are 100-percent cotton, 100-percent polyester, and 50–50 blends. Other fabrics will accept transfer within the limitations of heat durability. The fabric must withstand the 300°F heat applied under pressure for thirty seconds without scorching, burning, or melting. If you do not know how much heat the fabric will withstand, test it with a hot iron or in a dry-mount press.

To make a Xerox transfer print: (a) Check the color setting and place the original on the copy glass. (b) Place the transparency mode card in the paper tray, with transfer sheet on top, slick side down. (c) Make a color selection and press the "start print" button to produce a color transfer image in thirty-three seconds.

The texture of the fabric to receive the transfer is partly a design consideration, but this, too, will be restricted by the fabric's ability to accept and hold the transfer evenly. As a rule, the finer the texture, the more readily the transfer will adhere. You can test the appropriateness of fabric texture to the transfer image beforehand by applying a full or partial section of a printed sheet.

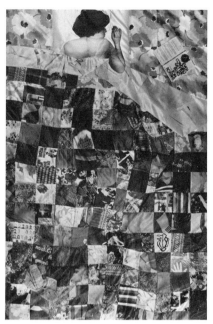

Numerous individual transfer prints were stitched together to form the quilt section of *Color Xerox Dream*, while the top portion of the fabric containing the figure and flower pattern was printed from transfer sheets mounted side by side. 5½' × 8'. Artist, Deborah Jo Fishler.

Printing Techniques

Making a faithful color reproduction of an original print can be as simple as pressing one button and waiting only thirty-three seconds for the transfer sheet or paper to cycle three times in the copier and emerge as a fully fused color print. However, this will not always be the case. The machine's color setting will affect the printed image's color density and may require adjustment for certain images. For printing with normal color density and contrast, the three color-adjustment controls under the right front panel of the copier are set on 3, in the middle of the dial. The key operator, who operates the machine, will check the color adjustment before the print is made and change the setting when necessary.

Before a transfer sheet is printed, a paper copy is run to compare the copy's color fidelity with the original. After the paper copy has been evaluated, the key operator may want to adjust the color control further. Once a satisfactory paper print has been made, she or he will prepare the machine for transfer printing. Complete instructions for using different types of transfer paper with color copiers are supplied by the manufacturer. When the thermoplastic sheet is used, the copy machine must be set in the "transparency" mode to keep the sheet from melting.

Transfer paper, coated with the thermoplastic binder, will absorb the toner, causing the printed transfer to appear less vivid than the equivalent print on paper. This color difference will become less evident once the print has been transferred onto fabric.

After a satisfactory transfer print has been run, it is often a good idea to make a second print on transfer paper at the same setting. This extra print can be used for experimentation or in case the first heat transfer attempt is unsuccessful.

Transfer Techniques

Even heat and pressure are vital to the success of the transfer process. The dry-mount press provides the most foolproof method of mounting heat transfers of all types. Instructions accompanying each type of paper will indicate the temperature setting required. The heat press setting is usually 300°F.

When the full image area is to be transferred, the printed transfer sheet ($8\frac{1}{2}'' \times 14''$) must be trimmed to remove the poorly printed top edge by which the paper was fed through the machine. You can either transfer the remaining image area (approximately $8\frac{1}{2}'' \times 13\frac{1}{2}''$) singly, or create a composite by mounting several transfer sheets or portions of sheets side by side. You can do so by using a large heat press that can accommodate the entire transfer area. Otherwise, you can mount transfer sheets individually with an iron.

Fabric to receive the transfer should be centered on the base of the dry-mount press. When exact placement of the transfer is necessary, the outside edges of the fabric on which the image is to be centered can be marked prior to its placement in the press. The transfer sheet is then laid face down on the right side of the fabric. Once the transfer is in place, a sheet of thin white paper should be placed over the sheet to prevent liquefied ink from damaging the press. After the press reaches full temperature, the heat press plate is lowered for thirty seconds with maximum

pressure. The fabric, with the attached transfer, is removed and the transfer backing is peeled away from the fabric immediately while it is still warm. To avoid stretching the fabric, you must remove the backing sheet carefully by applying even pressure in one direction. The peeled backing should retain only a faint outline of the inked image. If the transfer fails to peel evenly, leaving embedded ink in the backing, the transfer has not reached the proper temperature, or it has been allowed to cool before peeling. In either case, the procedure must be repeated.

The transferred image should become stable once it has cooled and should be resistant to rubbing or scratching with the fingernail. If the image flakes or rubs off, the transfer was not bonded properly and will not be permanent.

A dry-mount or heat press is not necessary for transferring small images that can be applied with an iron. To reach an adequate temperature for transfer, the "cotton" setting (300°F) or above will be required. But because heat is applied unevenly, many synthetic fabrics will stretch and cannot withstand iron-on transfers.

To help maintain an even heat level for transferring with an iron, a padded table or ironing board should be prepared with an aluminum-coated covering or a sheet of aluminum foil placed under the fabric in the transfer area. After the iron has reached full temperature, you can test the transfer procedure by adhering a scrap of transfer paper to a sample swatch of fabric. This successfully accomplished, place the transfer sheet face down on the fabric, cover it with a thin sheet of white paper to keep the ink from contaminating the iron, and apply the hot iron to the transfer area with firm, even pressure. Keep the iron in motion during transfer to avoid scorching the adjoining fabric and to aid in even adherence. Heat is applied for approximately thirty seconds; the test swatch made earlier is the best time indicator. The backing must be peeled away immediately. Spots of color left on the transfer sheet indicate uneven heat. Sections of a transfer can be reheated after the image is entirely covered with the original transfer backing.

Transferred images made with thermoplastic-coated sheets can be laundered but should not be subjected to excessive heat. Dryers should be set for delicate fabrics and a pressing cloth or foil cover must be used when the transfer area is ironed. Bleach cannot be used on fabrics containing a transfer.

After the transfer sheet is subjected to the proper degree of heat for the correct duration of time, peel it from the fabric immediately, taking care not to stretch the fabric.

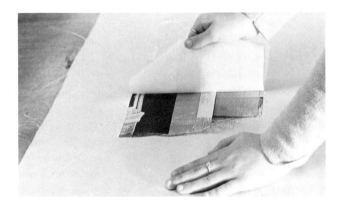

IV

Contact-Printing Processes

The Contact Print

Anyone familiar with darkroom work has printed contact proofs of negatives prior to enlargement. In addition to proofing negatives, the contact-printing procedure is vital to printing slow-speed sensitizers that cannot be projection-printed with an enlarger. In this application, however, 35mm negatives are too small to create a final print of intelligible size. Before contact printing can take place, the original film must be enlarged to create an image of the desired size (see Chapter II). For example, if a cyanotype-sensitized fabric offers a 12″ × 15″ printing area, a film enlargement of that size or slightly smaller would be needed. The full-size positive image can be printed when the negative film enlargement is placed in contact with the sensitized material, covered with glass to assure close contact and prevent movement, and exposed to an ultraviolet light source. Of course, if negatives larger than 35mm transparencies are used, it might be possible to eliminate the first step of enlargement.

Although contact printing requires a contact-printing frame larger than that normally found in the darkroom, the purchase of expensive, specialized equipment is not necessary. An initial contact-printing setup might include a flat printing surface such as a table, a one-inch layer of foam cushion, a sheet of black paper, a heavy piece of plate glass or clear Plexiglas, and direct sunlight. A more dependable apparatus, the contact-printing frame, can easily be constructed within the limits of a small budget. This is described in greater detail later in this chapter.

When a darkroom is not available, one option is to print a photogram as described in Chapter II. Another option is to employ a commercial photographic lab to create the oversize negative. In this case, some individual control must be sacrificed, but specific instructions to the lab will aid in retaining the desired qualities of the finished enlargement.

Contact-speed Sensitizers

In the broadest terms, a photo sensitizer is any substance that may be applied to a material to render that material light-sensitive. Photo sensitizers include a great variety of chemical solutions, dispersions, and emulsions with diverse compositions and light-sensitivity levels. For the sake of simplicity, sensitizers can be categorized by their use. Contact-speed sensitizers, because of their relatively slow speed and low light-sensitivity levels, require contact printing.

Contact-speed sensitizers are composed of light-sensitive chemicals usually suspended in water-base solutions. These liquids—or in some cases, semiliquids—facilitate the absorption of the sensitizer into a support material, such as a fabric, without distorting the material's texture or pliability. It is this quality that makes contact-speed sensitizers compatible with most fabrics.

Contact-speed sensitizers are rarely prepackaged. Weighing, measuring, and mixing are necessary to prepare the chemical solutions. A few photosensitive chemicals are available in local camera and photography supply shops, but most must be ordered directly from chemical companies. (See the list of suppliers at the end of the book.) In their dry state, photosensitive chemicals are packaged in opaque brown bottles to prevent light deterioration. Once mixed into solution, light sensitivity is generally short-lived, even in opaque containers. Contact-speed sensitizers must be mixed, applied, dried, and printed in rapid succession to retain maximum sensitivity.

Chemical hazards are a major concern in the preparation and handling of sensitizers. Most light-sensitive chemicals are poisonous if ingested, many are skin irritants, and others burn the eyes and lungs if misused. Safe handling of chemicals and chemical solutions must be a prime consideration in working with sensitizers. Each component chemical and its accompanying dangers should be understood before a solution is prepared. The workroom must be well ventilated. As a general rule, rubber gloves and protective clothing are always worn, and chemicals cannot be mixed in cooking utensils or near a food preparation area. Disposable plastic containers, stirrers, and paper cups are preferable for mixing and storing chemical solutions.

To achieve an interesting play of color and texture, a positive film used for contact printing the cyanotype image on fabric was mounted over the fabric print. 11½ × 7". Artist, Sherry Fatla.

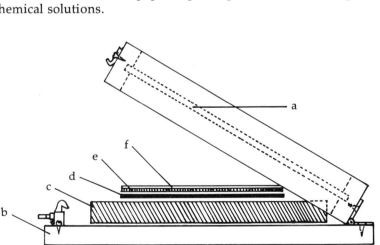

A contact printing frame: (a) ¼ inch plate glass mounted in 1¼ inch wooden frame. (b) Frame is hinged to ¾ inch plywood base with elbow catch. (c) 1 to 2 inch layer of foam padding fits *inside* the frame. (d) Layer of black paper or felt. (e) Sensitized fabric. (f) Film negative, emulsion side down.

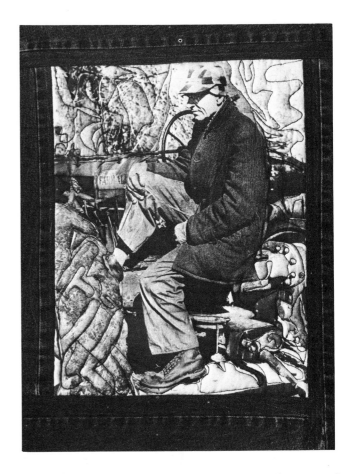

left: In a very different type of design, portraits of students were printed on fabric with cyanotype and incorporated into hand puppets. Artist, Amy Schaffnit.

right: Bert, a cyanotype image on cotton with machine quilting, is an example of a finely detailed print attained through the skillfull use of the contact-printing process. 21" × 23". Artist, Mary Stieglitz.

Techniques for applying sensitizers will vary according to the type of fabric or other support material. Fabric is usually dipped and soaked in the sensitizing solution, then hung in a light-safe area to dry before printing. After exposure to ultraviolet light, the printed image is developed in plain water or a chemical bath to amplify the image color and wash away any soluble chemicals that remain after exposure.

Design

Each sensitizer produces prints with distinct visual characteristics: cyanotype images are blue and white, Vandyke prints are dark brown and white, and gum images may be printed in full color. Slow-speed sensitizers are particularly well suited to the creation of photographic images on fabrics, but they can also be used to sensitize paper, leather, and other types of porous materials.

The choice of the optimum sensitizer for a particular work depends on your concept and knowledge of how a sensitizer might be used to accomplish this goal. As a general rule, the faster the speed (light sensitivity) of the sensitizer, the greater detail the final print will have. Following this principle, you would choose a Vandyke sensitizer to print photos requiring maximum detail from a normal negative. Slower sensitizers or those with less light sensitivity, such as Inkodye, might be used for printing high-contrast negatives without intermediate tones.

Clarity of details in print reproduction is only one factor to be weighed. Other considerations include color in the final print, the context or subject matter of the negative, the support material, and the pictorial quality desired in the final image.

Cyanotype

Discovered by Sir John Herschel in 1842, cyanotype was one of the first nonsilver processes used to create photographic images. Yet, because of the popular acceptance of the daguerreotype and the greater stability of the silver processes, cyanotype failed to gain acceptance in the mainstream of modern photography. Instead, it was adopted as a copying technique used to reproduce large mechanical and architectual drawings. It became known by the term "blueprint" because of its blue background reproductions. The actual compounding of cyanotype chemicals became obsolete as presensitized blueprint paper entered the market.

But for the artist who is interested in recreating the original process, cyanotype remains one of the least expensive and most effective processes for printing photographic images. It permits great variety in both mood and color and is especially effective on fabrics. The depth of the brilliant blue contributes an ultra-reality to photo images that is not found in the characteristic black-and-white photographs printed on paper.

The cyanotype process is also versatile. A blueprint can be transformed into a brownprint (the color of a Vandyke) by a simple reduction and

left: A bold cyanotype image of a house was collaged with black-and-white photograph of a family to create this dramatic composition built on visual contrasts. 21″ × 21½″. Artist, Tom Petrillo.

right: The distinctive character of a cyanotype image becomes evident in this composition that combines a black-and-white photograph with a cyanotype of comparable contrast. 19″ × 23″. Artist, Tom Petrillo.

conversion process. Additionally, the basic sensitizing formula can be altered to produce an image reversal resulting in a positive image printed from a film positive. Cyanotype images may be hand-colored, and their compatibility with Inkodyes permits multicolored images to be printed over or under the primary blueprinted image.

Cyanotype, compared with silver nitrate–based sensitizers, is relatively slow. Fine-detailed prints are possible but require a longer exposure time than the equivalent image printed by a silver process. Blueprints are also considered less permanent, since they tend to fade if exposed to direct sunlight over a period of time.

In spite of these limitations, cyanotype is perhaps the most practical process for initial experimentation. Two relatively inexpensive chemicals are combined with water to create the two-part sensitizing solution. A material sensitized with this solution is printed by ultraviolet light, transforming soluble ferric salts into insoluble ferrous salts. The unexposed ferric salts are then washed away, leaving a brilliant blue cyanotype image.

PREPARATION FOR PRINTING

Work Area

A fully prepared work area is organized before the sensitizing procedure begins.

A light-safe area is needed for both sensitizing and drying the fabric. You should prepare the room by closing out all natural light and replacing the normal light bulb with a low-wattage, yellow "bug light" that is at least four feet from the sensitizing table. Fluorescent light cannot be used.

A drying area should be established equipped with clothesline and several clip-type clothespins. Whenever feasible, the clothesline should be strung over a bathtub to catch drips and splatters. Otherwise, the drip area under the clothesline must be covered with layers of newspapers.

All worktables and the floor area should also be fully covered with plastic or newspapers. Other materials needed for applying the solution can be assembled in the work area. Adequate preparation will avoid an extensive cleanup later. (This holds true for all sensitizers covered in this chapter.)

Materials used in the preparation of a cyanotype solution.

Fabric

Only 100-percent cotton, linen, or other natural fibers without special finishes will readily accept a cyanotype solution. New fabrics purchased for printing must be washed thoroughly or boiled to remove all sizing. Boiling the fabric for several minutes is the most satisfactory way to dislodge stubborn sizing in most fabrics. Once the fabric is clean and cut to the appropriate size, iron each piece before sensitizing.

Because 100-percent untreated natural fibers are not usually found in local fabric shops, they must be ordered (see List of Suppliers). It may be more economical and convenient, however, to begin a printing project with used fabrics. Muslin, percale sheets, and fine old linen tablecloths are often available at second-hand stores. They are inexpensive, and they encourage experimentation that might be inhibited with more costly fabrics. One large bed sheet will supply a number of pieces of fabric, along with several test strips for exposure control.

Test strips are small swatches of fabric (approximately 2″ × 4″) cut from the primary fabric that is to be sensitized. They are vital to the success of printing, since you can use them to test the exposure time and the color of the finished print. Each test strip should be marked to match its companion fabric. To make sure that the fabric and test strips will be equally sensitive, both are sensitized simultaneously.

Test strips must accompany fabric into the sensitizing bath and may be loosely attached to the main fabric with a safety pin.

Materials for Sensitizing

chemicals: ferric ammonium citrate, potassium ferricyanide

2 brown or foil-covered storage bottles (glass or plastic, ½-gallon capacity)

gram scale (available in the dietary section of a drug store)

filter paper (cone-shaped coffee filters will work)

funnel

distilled water

darkroom graduate or measuring cup

mixing container

rubber gloves and protective clothing

paper cups and plastic spoons

newspapers

To mix a sensitizing solution: (a) Weigh the dry chemical on the gram scale. (b) After the chemical has been dissolved in distilled water, you can filter it into an opaque storage bottle for later use.

Application, method I: Small pieces of fabric may be sensitized in a developing tray, whereas fabric yardage will require a deep plastic container. The fabric is immersed in the solution for three minutes.

photo developing tray or deep plastic container (according to size of fabric)

polyfoam brush (if solution is painted on)

Mixing

Solution A: 50 grams of ferric ammonium citrate (green) dissolved in 250 milliliters (1 cup) distilled water

Solution B: 35 grams of potassium ferricyanide (poisonous*) dissolved in 250 milliliters (1 cup) distilled water

Prepare solution A first. Determine the gram weight by placing an empty paper cup on the gram scale and checking its weight. Add to this empty cup weight 50 grams (g) of ferric ammonium citrate. Place the dry chemical in a mixing vessel and add 250 milliliters (ml) of distilled water. Stir until dissolved. Insert a paper filter into a funnel and pour the dissolved solution through the filter into the storage bottle. Cap this solution, discarding the paper and paper cup. Wash the funnel, stirring spoon, mixing vessel, and rubber gloves.

Prepare solution B in the same manner, except weigh 35 g potassium ferricyanide and mix it with 250 ml distilled water. Filter the solution into a separate storage bottle and then discard the filter paper, paper cup, and plastic spoon. Wash the mixing area thoroughly.

When stored separately in tightly capped opaque bottles, solutions A and B have a shelf life of up to four months.

APPLICATION

Method I

A mixture composed of equal parts of solutions A and B forms the actual sensitizer. Before preparing the sensitizer mixture, estimate how much solution you will need for the fabric involved. This will vary greatly depending on the fabric's absorbency. When this is unknown, prepare a small amount first (for example, 125 ml A and 125 ml B). Additional amounts can easily be mixed, whereas an excess cannot be stored.

Mix the solution in a container big enough to allow for total coverage of the fabric. A clean, photographic developing tray is practical for small pieces of fabric that will lie flat. A larger, deep plastic container, such as a waste can, will be needed for fabric yardage that must be submerged in the solution.

Cyanotype solutions will appear yellow-green under safelight conditions. Once the solution begins to drip from the sensitized material during drying, a dark, dyelike substance will result.

The sensitivity life of the A/B mixture in solution is only about six hours. Sensitize each piece of fabric with its accompanying test strips by sub-

* Potassium ferricyanide is highly poisonous if swallowed and must be handled with extreme care. Wear rubber gloves when you mix and apply the solution. Destroy paper cups, plastic spoons, and filter paper after mixing the ferricyanide solution. Thoroughly wash gloves and mixing containers after each use. Never use food containers for mixing the solution. When children are involved in the learning process, the safest procedure is to permit them to observe the mixing and sensitizing procedures, and to let them participate only in the final printing of the dry, sensitized fabric.

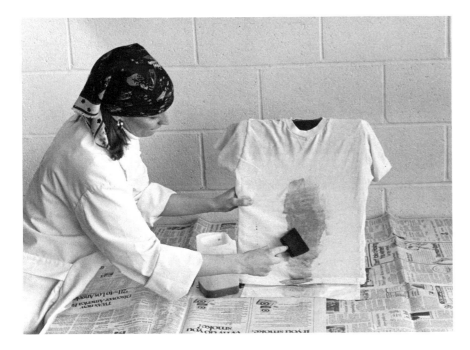

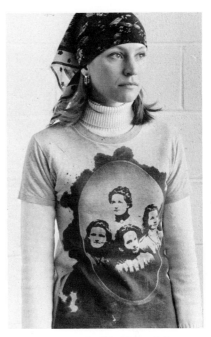

Application, method II: (a) A polyfoam brush dipped in solution is used to paint sensitizer onto a tee shirt. Stiff cardboard lined with plastic plus a fabric blotter protects the reverse side of the shirt from the sensitizer. (b) A free-form image area, produced by brushing on sensitizer, is used as a background for the printed portrait of Victorian ladies.

merging them in the solution for about three minutes. Gently squeeze out all excess solution, allowing it to drain back into the container. The fabric and test strips are now ready to be hung in a light-safe area for drying.

Method II

Total submersion of a fabric into a sensitizing solution will produce a cloth with overall sensitivity. After the sensitized fabric is exposed and developed, a blue-bordered, blue-and-white print will result. This type of image effect may not always be desirable, however. An alternative method is to sensitize only specific areas, leaving the outlying color of the fabric unchanged.

For a freeform image area, a blotting material can be used to absorb the excess solution and aid in manipulating the liquid. An old drawing board or stiff cardboard covered with a plastic bag makes a good work surface. You can then top it with a layer of absorbent cotton fabric, which acts as a blotter. The size of the blotter must be larger than the area to be sensitized. When a two-layer garment, such as a tee shirt, is to be sensitized, insert the blotter board inside the garment.

You can use a pencil to make a faint outline of the general area to be sensitized to help place the solution. A polyfoam brush affords maximum control for applying the liquid evenly and confining the solution to the outline area. Apply the sensitizer first in the center of the area. Closely observe the saturation of the fabric and control it by painting small sections, allowing them to flow through the fabric until the entire area is covered. Test strips are also painted with the solution when this method is used.

Following sensitizing, the fabric should remain on the layered blotter for several minutes or until all the excess solution is absorbed. Garments sensitized in this manner cannot be hung vertically to dry since wet sen-

sitizer could spread down into dry layers of the clothing. Therefore, hang the sensitized fabric or drape it in a horizontal position to permit the solution to drip from the center of the sensitized area. Pin two corners of the fabric on one clothesline and the other two corners on an adjacent clothesline. If you are working with a two-layer garment, allow the plastic-covered cardboard to remain between the two layers of the garment while it dries in a horizontal position.

Method III

Method III is similiar in intent to method II, except that method III attempts to define the sensitized area in a more exacting way by confining the image through masking or resist techniques.

The traditional resist of beeswax and paraffin can be used. However, wax stiffens the fabric and must be applied well out of the image area to allow for proper contact between the negative and the sensitized fabric. A simpler, and usually better, method is to use a prepared dye resist. For example, Inkodye resist washes out of the fabric with warm water and will not transfer onto the negative during contact printing.

By using resist techniques, you can print small photo images on large expanses of fabric, creating the illusion of three-dimensional space within a flat plane. You can do this by applying resist to individual areas within the fabric's field.

The proposed image area is first lightly outlined on the fabric with a pencil. This indicates where to place the resist. In addition to the resist, masking tape is also used to block the flow of solution in evenly woven fabrics. Masking tape is applied outside the image area, about one inch away from the pencil line, with all corners of tape overlapping. The open space that remains between the tape and the line is filled with resist, which slightly overlaps the masking tape. After the first coat of resist is dry, the fabric is reversed; resist is applied to the back, directly over the front coat. When the second coat is dry, the resist is covered with a line of masking tape. This space inside the tape, which will be the image area of the print, is now ready to be sensitized.

Application, method III: (a) An area to be masked is first taped, then painted with a line of resist. This procedure is repeated on the reverse side of the fabric. (b) Masking allows the image area to be controlled. Here, several images (detail of one shown) have been printed on a 1950s-vintage flowered tablecloth.

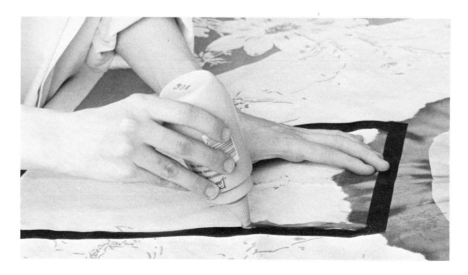

The area to be sensitized is placed on top of a fabric blotter, as in method II. The sensitizer is painted onto the fabric, beginning at the center, and allowed to spread toward the resist lines. Test strips are also painted with sensitizer. The fabric blotter is removed after it has absorbed the excess solution. The sensitized portions of the fabric can be dried flat, hung in a "V" position over two clotheslines, or draped over an open box or picture frame with the center at the lowest point so the solution does not drip onto other areas of fabric.

Method IV

Although an even coating of the sensitizer is usually considered a prerequisite for a successful print, it can be varied according to the artist's idea. Because of the solution's liquid state and the fiber's absorbency, a variety of dye techniques can be used to sensitize fabrics, yarns, and fibers. For instance, you can paint a photo sensitizer onto warp threads, either prior to weaving to create an ikat dyed warp, or after the fabric has been woven but while it is still on the loom. Apply the sensitizer and allow it to dry. Place the negative over the sensitized area, cover it with plate glass, and expose it to ultraviolet light. If you use a portable frame loom, you can expose the image outside and develop it by rinsing it in the running water from a hose. Developing an image on a warped floor loom presents more difficulty. You must pour the water carefully over the image area and catch in a container underneath to prevent water damage to the loom.

One of the most effective adaptions of photo sensitizing is tie dyeing. Procedures for tying fabric to receive a sensitizing bath are essentially the same as those used with a dye bath. The primary difference is that the patterns will vary in light sensitivity as well as color intensity. The character of the sensitized patterns after drying are determined by when the ties are removed. Feathery, soft patterns are achieved when the ties are cut while the sensitizer remains moist, whereas hard-edged lines are produced when ties are cut after the solution is totally dry. Test strips are treated in the same manner as the primary fiber or fabric.

Tie dyeing unevenly distributes photosensitive material, so it is excellent for printing photograms. The graduations in color as well as sensitivity yield dramatic patterns of dark and light that can become the backdrop for textural shapes and related images.

PRINTING

Materials

Sensitized fabric and test strips should be completely dry, and can be pressed with a warm iron before being printed. Cyanotype is most light-sensitive immediately upon drying, so ideally it should not be stored over a day or two.

Information on how to prepare film or paper negatives for contact printing is contained in Chapter II.

A contact printing frame or a vacuum printing frame should be used to hold the negative in contact with the sensitized fabric for printing. Since very few people have access to a professional vacuum frame, less sophisticated gear may be substituted. A simple contact printer can be constructed

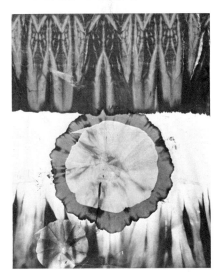

Application, method IV: (a) To further control the flow of sensitizer into tied fabric, a plastic bag is secured over portions of the fabric that are not to receive the sensitizer. (b) Photographic images printed on tie-dyed sensitized fabric reflect the uneven distribution of the solution.

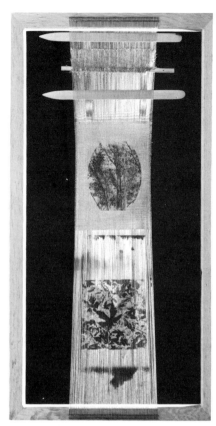

In *Loom Series II*, cyanotype sensitizer was painted directly on the warp threads and portions of the woven fabric. This type of portable frame loom facilitates development. 19″ × 36″. Artist, Sylvia Seventy.

from a two-inch-thick layer of foam padding covered with black paper and topped with a piece of heavy nonglare plate glass. This sandwich, placed on a level table in direct sunlight, is sufficient for contact printing at the simplest level.

A slightly more efficient apparatus can be constructed from a piece of glass or clear Plexiglas framed in wood. A discarded wood-framed window with clear, unmarred glass is one possibility. The framed glass provides even more control when it is hinged at the base to a piece of ¾-inch plywood or to a worktable. The front of the frame can be clamped or latched to the wood to align registration during exposure. With this type of contact frame, the foam padding must be cut to fit inside the frame to exert even pressure throughout the contact area. A hinged frame also permits examination of exposures during printing, facilitates the removal of test strips, and enables one person to complete the operation without assistance.

Light sources will vary according to need. Direct sunlight is not reliable in many climates. Although ultraviolet light will expose sensitized fabric on cloudy days, printing is slow, requiring ten to fifteen minutes longer. Exact exposure time must be determined through the use of multiple test strips. Other light sources recommended for exposing cyanotypes are sunlamp bulbs and quartz or fluorescent lights. With a constant light source, time exposures can be more exacting. Variations occur only after the light source begins to weaken with age.

Exposing the Fabric

The positioning of the printing table or contact frame will depend on the available light source. For printing with artificial light, the film can be positioned on the fabric in a dimly lit area to avoid premature exposure. Preparations for sun exposures are usually more involved since the equipment must be moved to a sunlit location outdoors. Ideally, the negative should be positioned on the fabric in a light-safe area. The contact frame is then clamped tightly and the entire sandwich moved into the sunlight for exposure. Without a hinged contact frame, the printing area must be prepared outside. The sensitized fabric is then transported in an opaque plastic bag, placed on the black covered pad, topped with the negative, and covered with heavy glass. Test strips are exposed at the same time but cannot be placed within the image area. The printing area should be large enough to accommodate the test strips without necessitating overlaps of the sensitized fabric.

Printing a cyanotype-sensitized fabric in direct sunlight with a film negative will take from fifteen to thirty minutes, depending on the color of blue desired, the fabric, quality of light, and so on. Paper or other types of negatives will vary this time considerably. Exposures made indoors under a sunlamp positioned fourteen inches from the negative will take up to twenty minutes, depending on the age of the bulb. Test strips are vital to achieve a controlled exposure; they are always exposed at the same time as the primary image. Three or more test strips are positioned so that they may be removed from the contact frame without disturbing the contact film. After ten minutes of exposure, the first test strip is pulled. The exposed but undeveloped image will appear yellow-green. This is helpful

left: A simple, easily assembled printing frame can be constructed from a storm window fitted with an inner cushion of foam that is lined with black paper. However, the framed window must be heavy enough to hold the negative in tight contact with the sensitized fabric.

in indicating exposure, but only to the experienced eye. To check actual print color, you must develop the exposed strip immediately by washing it in a bucket of plain water. Test strips should be pulled and developed every five minutes thereafter, or until the deep blue color of a fully printed cyanotype is reached.

Developing the Image

Following exposure, the fabric is removed from the printing frame and washed immediately in cool running water to develop and fix the cyanotype image. When a water source is not available, the fabric is transported in an opaque plastic bag to prevent additional exposure. After the fabric is placed in water, a bright blue image should appear. The yellow residue that is apparent in the nonexposed areas must be totally washed away, clearing the background color of the fabric. Blue stains that remain in the background area indicate overexposure.

After washing, the fabric is gently squeezed, smoothed, and hung in a dark place to dry. The print's wet color is always more vibrant than the final dry color.

Intensifying the Color

If solutions were properly mixed and exposure time is correct, a rich blue image should be produced. However, if during development the color of the wet image appears dull, the blue can be intensified with an additional step. After the print has been thoroughly washed in plain water, it can be submerged in a three-percent solution of household hydrogen peroxide. After a minute or so in the intensifier bath, a color change should become evident. The cyanotype print is then removed from the solution and washed in plain water for twenty minutes or until all traces of the peroxide are removed.

When an unhinged printing frame is used, test strips must be made extra long so that they can be removed easily from the frame without disturbing the film registration on the main fabric.

The printed fabric is washed in a stream of running water, which circulates around but does not pound the printed image.

CONVERSION

Cyanotype conversion is a method of creating brown-toned images from blue cyanotype prints. Although the coloration of the converted image is

generally less dramatic than those produced directly from silver nitrate-based sensitizers, such as the Vandyke, this process does make use of inexpensive, readily available chemicals.

Brown-tone cyanotype conversion is completed in three steps: color removal, color replacement, and washing.

Prepare a strong solution of 28.4 g ammonia to 240 ml distilled water. This is an amount sufficient to reduce the color of an 8″ × 10″ image area or smaller, depending on the thickness of the fabric and the density of the color. Submerge the dry fabric completely and stir for about five minutes or until only a faint image remains. Rinse with plain running water to remove the ammonia solution.

Prepare a solution of 14 g tannic acid (used in winemaking) dissolved with 750 ml distilled water. Submerge the fabric and agitate it in the acid bath until the desired tone is achieved. After approximately fifteen minutes, the fabric will have reached a maximum brown-tone. If a darker tone is desired, a few drops of ammonia will help intensify the color.

The final step is to wash the fabric in plain running water for thirty minutes and hang it to dry.

POSITIVE CYANOTYPE (PELLET) PROCESS

The positive cyanotype process, called the Pellet process after its discoverer, H. Pellet, produces a total reversal of the image areas developed by the regular cyanotype process. A positive image is produced from a film positive, and a negative image results when a film negative is exposed. The sensitizing formula consists of three basic solutions:

Solution A: 20 parts gum arabic dissolved in 100 parts water

Solution B: 50 parts ferric ammonium citrate dissolved in 100 parts water

Solution C: 50 parts ferric chloride to 100 parts water

The three solutions are then combined in the following order and proportions:

Solution A: 20 parts

Solution B: 8 parts

Solution C: 5 parts

The mixture's color and consistency will change as each solution is added. Once the three-part solution is completely mixed, however, the final liquid should be almost clear.

Fabric is then sensitized with this formula, dried, and contact-printed by means of the same procedures for regular cyanotype. The printed image is first rinsed in running water and then immersed in a solution of 20 parts potassium ferricyanide to 100 parts water. The final step will develop the characteristic blue of the cyanotype. After developing, the printed fabric is washed in plain water and hung to dry in a dark area.

CARE OF THE CYANOTYPE

Cyanotype images printed on fabrics free from sizing should be able to withstand laundering with mild soap (never bleach) in cold water. If, over a long period, blueprinted images begin to fade, it is usually possible to revive the color. Placing the faded fabric in a cool, dark, slightly damp area for several weeks will often help restore original color. Another method is to immerse the print in a very weak (50:1) solution of hydrogen peroxide.

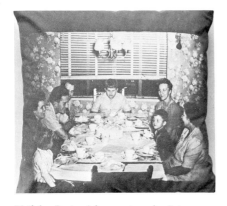

Birthday Party. A brown-toned print created by the conversion of a cyanotype image. 15½″ × 14½″ × 4″.

In *Soft Triptych*, a Vandyke print on cotton with quilting, makes excellent use of the sensitizer to enhance the antique quality of the old photographs. 48″ × 17″. Artist, Mary Stieglitz.

Vandyke

The Vandyke sensitizer is a silver nitrate-based, three-part solution, which is mixed and applied much in the same manner as the cyanotype solution. The distinctive brown-black color of the printed image (known as Vandyke brown) is fixed after the image has been developed in plain water.

With a color reminiscent of early paper prints, the Vandyke—sometimes called a brown print—is quite different in feeling and character from the cyanotype. Both are well suited to the development of images on fabric.

Technically, the Vandyke sensitizer has the advantage of being faster than the ferric salt-based cyanotype. Because of this greater degree of sensitivity, fine detailed negatives can be printed in approximately one-third the exposure time required for the cyanotype when an equivalent light source is used.

Cost may be a major factor when the Vandyke sensitizer is being considered. Silver nitrate is costly compared with chemicals required for a cyanotype solution, making this process less economical for experimentation.* When cost is not a factor and a brown-toned image is desired, however, a slightly less hazardous kit form of the Vandyke sensitizer is available with premeasured chemicals from Rockland Colloid Corporation. (See list of suppliers in the back of the book.)

* *Silver nitrate, the basic chemical in the Vandyke sensitizer, is potentially dangerous. Long rubber gloves and protective clothing should be worn during the entire mixing and sensitizing process. In the dry state, it can burn the eyes and skin or even injure the lungs when inhaled. In the liquid state, it can also burn the eyes and skin. If accidental contact is made with the chemical or chemical solution, flush the area immediately with plain water.*

PREPARATION FOR PRINTING

Materials for Sensitizing

chemicals: ferric ammonium citrate, tartaric acid, silver nitrate

1 brown or foil-covered storage bottle (at least 1-liter capacity)

gram scale (available in the dietary section of drug stores)

funnel

distilled water

darkroom graduate

3 mixing containers (glass, plastic, or stainless steel)

rubber gloves and protective clothing

paper cups and plastic spoons

newspapers

Mixing

Solution A: 90 g ferric ammonium citrate dissolved in 237 ml (8 oz.) distilled water

Solution B: 15 g tartaric acid dissolved in 237 ml (8 oz.) distilled water

Solution C: 37.5 g silver nitrate dissolved in 237 ml (8 oz.) distilled water

Prepare solution A first. Determine the gram weight by placing an empty paper cup on the gram scale and checking its weight. Add to this weight 90 g ferric ammonium citrate. Place it in a 1-liter mixing container and add 237 ml water. Stir until dissolved. Prepare solution B by weighing out 15 g tartaric acid. Add 237 ml distilled water. Solution C consists of 37.5 g silver nitrate dissolved in the 237 ml distilled water in a third container. Then mix solution B with solution A. Slowly add solution C (silver nitrate) to the A/B solution while stirring. The solution is complete when enough distilled water is added to produce 1 liter of liquid.

When stored in a tightly capped, opaque bottle, this sensitizing solution will have a shelf life of up to four months.

Materials used in the preparation of a Van-dyke solution.

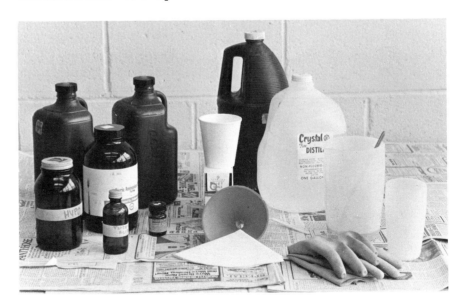

APPLICATION

The Vandyke sensitizer can be applied by total submersion, it can be brushed on, or the sensitized area can be restricted by masking, batik, or tie dyeing. These applications are the same as those described for the cyanotype process.

PRINTING

Exposing the Fabric

Exposure time for Vandyke-sensitized fabric will vary considerably, depending on the ultraviolet light source and the type of negative used.

Upon exposure, details of the image gradually become apparent in the highlight areas, but the exact exposure time for the desired color must be determined through the use of test strips.

The intense light of a carbon arc lamp will expose the fabric immediately, whereas a single sunlamp placed 14 inches from the contact frame will take from five to fifteen minutes. Test strips should be developed after the first minute and at four-minute intervals thereafter. This procedure is also applicable for sun exposures.

Developing the Image

 Materials: running water (65°F–75°F)

 washing container

 hypo solution: 28 g sodium thiosulfate dissolved in 591 ml water

Immerse the exposed print in a container filled with warm running water for about one minute. The yellow image that appears should exhibit the density of a fully developed exposure. You transform this initial image into a brown print by placing it in the hypo bath for exactly five minutes. When the print is overexposed, fixing time can be extended to allow the hypo to partially reduce the image's density. If it is underexposed, the print should be allowed to develop naturally in the sunlight without hypo fixer. For another color variation, you can press the freshly washed, unfixed print with a hot iron until the yellow image appears black.

A Vandyke-printed photo was used in combination with a colorful batik-dyed fabric to create *Landscape*. 10″ × 14″. Artist, Rowen Schussheim.

Rockland Fabric Sensitizer FA-1

Rockland Fabric Sensitizer is generally comparable to the Vandyke sensitizer both in the color and in the quality it produces. However, mixing is simplified since all dry chemicals are premeasured and require only water to prepare the sensitizing solution.

PREPARATION FOR PRINTING

Fabric

Individual sensitizers will vary slightly from one fabric to another. In this case, as well as with the processes previously described, 100-percent untreated cotton is a predictable fabric with which to begin.

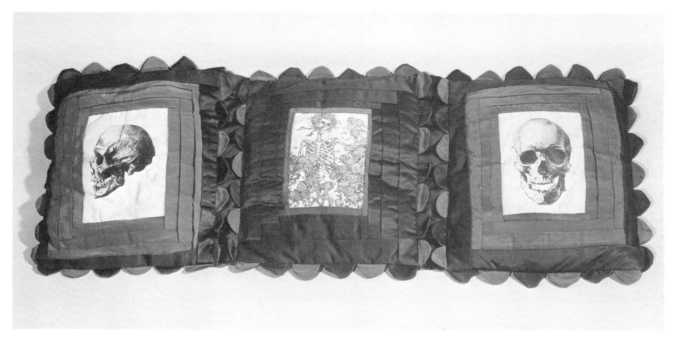

The artist created *Icon* by printing photos onto Rockland-sensitized cotton. The deep brown color was created when the developed image was ironed while the fabric was still damp. Images were tinted with watercolor and framed in satin. Artist, William O. Huggins.

Materials for Sensitizing

Rockland FA-1 fabric sensitizer

2 opaque storage bottles ($\frac{1}{2}$-gallon capacity)

1 regular storage bottle (1-gallon capacity)

1 gallon distilled water

funnel

mixing containers (glass, plastic, or stainless steel)

stirrer

rubber gloves and protective clothing

newspapers

Mixing

Prepare the solution packet labeled one-A by dissolving the contents in one-half gallon distilled water. Funnel the solution into an opaque storage bottle. Then dissolve solution one-B in one-half gallon of distilled water and pour it into the second opaque bottle.*

Create the final solution under safelighted conditions by mixing equal parts of one-A and one-B in a container of adequate size for sensitizing fabrics. This two-part solution will gradually lose its sensitivity and should be mixed as needed. If stored in total darkness, the solution can remain active for up to two days.

* *Silver nitrate is a hazardous chemical that can burn the eyes and skin and possibly injure the lungs if inhaled.*

APPLICATION

Equipment, application procedure, and exposure are the same as those used with the cyanotype and the Vandyke sensitizers.

PRINTING

Developing the Image

Materials: cool running water

washing container

hypo solution—Rockland pack #2 dissolved in 1 gallon of cool tap water

Develop the image in cool running water for about one minute; it should appear orange-brown and have the full density of a developed print. Fix the image in the hypo bath (Rockland pack #2) for five to fifteen seconds to obtain the final dark brown-black color. Longer immersion will not darken the color, but rather will cause the image to fade. This is desirable only for the reduction of overexposed prints.

After the hypo bath, wash the fabric in cool running water until all the unexposed sensitizer has been removed and the background is cleared. Then hang the printed fabric to dry in semidarkness.

CARE OF BROWN PRINTED IMAGES

Vandyke and Rockland images are permanent when printed on natural, untreated fabrics and can be laundered without loss of color. However, bleach should never be used unless partial or total removal of an image is desired.

In *Yo-Yo Banner*, (a) hand-sewn fabric yo-yos were joined and printed with an old family portrait using a Rockland Fabric Sensitizer. 23" square. Artist, Cindy Sagen. (b) Detail.

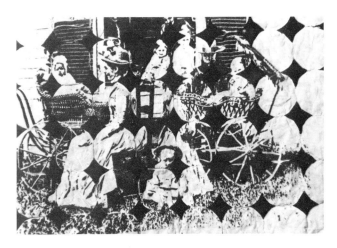

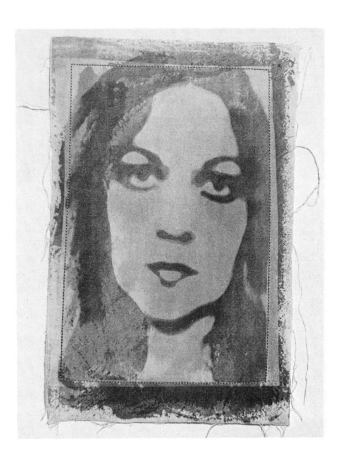

The transparent quality of an Inkodye is evident in *Sheryl*, a multicolor print on muslin with silk thread stitching. Artist, Sherry Fatla.

Inkodye

Inkodyes are permanent vat dyes whose light sensitivity is based on the leuco compound, which is sensitive to both natural light and air. It is usually used with direct exposure to sunlight. A positive photo image is produced when an enlarged negative is contact-printed on the Inkodye-sensitized fabric. The dye remains soluble in the unexposed portions of the fabric, while color pigment is deposited into the fabric in those portions exposed to ultraviolet light.

Inkodye is available in a full range of colors, including a clear extender. The gel-like concentrated colors appear almost colorless as they come from the bottle. All colors require dilution with either water or clear extender, depending on the method of application. Lighter color values result as the ratio of extender or water to the color is increased. When extended, Inkodye yields the transparent quality of a watercolor, making it possible to apply one color over the initial printed image to produce a third tone. Thus full-color prints are feasible if film color separations have been prepared, providing a separate negative for each primary color. When colors are printed on top of one another, a full-color image is produced.

Inkodye has a comparatively low light-sensitivity level and cannot reproduce an image with a full tonal range. Inkodye colors are most effective when printed from high-contrast negatives or as direct photograms. To

compensate further for its low sensitivity, Inkodye color can be printed over or under finely detailed cyanotype images to create a full-color print with both clarity and contrast.

PREPARATION FOR PRINTING

Work Area

Since Inkodye has a low light-sensitivity level compared with the sensitizers previously covered, work can be carried out in dim artificial light, well away from direct natural light. Inkodye will remain soluble in light-safe conditions and becomes permanent only after exposure, development, and heat setting. A dark drying area such as that recommended for the cyanotype should be provided to hang wet sensitized fabric.

To ensure a speedy clean-up, cover all work surfaces. Wear protective clothing and rubber gloves. Since the odor of the dye is unpleasant, carry out the work in a well-ventilated room.

The size and shape of the dye containers will vary according to the method of application. A deep container permits submersion of the fabric, while a plastic-covered cookie sheet is a good surface on which to place the fabric while you paint on the dyes.

Fabric

Untreated cotton, linen, rayon, and raw silk will accept Inkodye. New fabric should be washed thoroughly to remove sizing. When necessary, the fabric may be pressed before sensitizing. Fabric of unknown composition and/or fabric blends should always be tested to determine their capacity for accepting the dyes. White or light-colored fabrics are best for dye application. As with all fabric sensitizers, small (2″ × 4″) test strips should be prepared corresponding to the larger pieces planned.

Materials for Sensitizing

Inkodye colors

Inkodye extender (Clear)

Inkodye resist (where needed)

distilled water

polyfoam brush

mixing containers

darkroom graduate or measuring cup

rubber gloves and protective clothing

plastic spoons

newspapers

Mixing

As mentioned, Inkodye concentrated colors must be extended with water or Inkodye Clear extender to form a sensitizing solution. The solution depends on the method of application planned. Fabric may be dipped into water-diluted dyes, whereas dyes extended with Clear extender maintain their gel consistency and can be applied with a brush.

To determine color for final print, paint test strips with the diluted dye and develop them while they are still damp by processing them with a hot iron.

Color blending becomes a major consideration when preparing Ink-odyes. The dyes are available in the twelve spectral hues, plus brown and black, making it possible to mix or blend almost any shade from the basic concentrates. At the simplest level, one part blue dye diluted with two parts water results in a vivid blue, whereas one part blue dye diluted with five or more parts water or Clear produces a pastel blue. To obtain darker shades, small amounts of brown are added to the basic color, which has been diluted to the desired value.

Although the procedure for mixing the dyes is essentially the same as that used for mixing color in other media, Inkodyes present a special problem in that colors cannot be mixed by sight. The actual color of the dye will not become visible until it has been developed, and therefore it is imperative to test each color mixture before it is used on the final piece. To make a quick color check, saturate test strips with dye and develop them immediately (while wet) by pressing them with a hot iron. Successful color creation will depend on accurate record keeping and careful measurement of the quantities of basic colors and extender. It is helpful to write formula data on the back of each test strip as it is developed. These strips can be mounted in a notebook for later reference.

APPLICATION

Method I

When sensitizing an entire piece of material, submerge the fabric in a deep container of dye diluted with water until it is totally saturated (approximately three to five minutes). Another technique is to place the fabric in a wide-mouthed jar filled with the dye bath, cap the jar, and shake it until the dye has penetrated the fabric. However, the soaking method is better if some areas of the fabric have received a coat of resist.

Method II

Methods for painting on the sensitizer and masking with Inkodye resist are the same as those for the cyanotype process.

Method III

Because of their low light-sensitivity levels, Inkodyes can be combined with cyanotype images to produce a two-color print. In this application, both positive and negative film of the same image is required. First the positive film is placed over an Inkodye-sensitized fabric and printed. After this image is dry and has been fixed by pressing with a hot iron, the fabric can be resensitized in a cyanotype solution, as described at the beginning of this chapter. The dry fabric is then exposed under the negative image that has been carefully registered with the printed positive image on the fabric. Multicolored prints are also possible when color separations of film images have been prepared (see Chapter II).

PRINTING

Materials

Contact-printing equipment necessary for exposing Inkodye-sensitized fabric is the same as that required for cyanotype. Before it is printed, the sensitized fabric *cannot* be stored for later exposure, dried with heat, or pressed with an iron.

The preferred light source for printing Inkodye colors is direct sunlight. An already lengthy exposure time must be almost doubled when sunlamps or photoflood lamps are used indoors.

Exposing the Fabric

Expose Inkodye-sensitized fabric while it is damp to assure maximum sensitivity. Expose it in contact with a negative using the procedure described for cyanotype. You can pin damp fabric to the underlying foam layer to hold it taut during exposure. Make test strips to help determine the proper exposure time; this will vary with each color. It is important to allow maximum exposure time for dye-sensitized fabric. Overexposure is rarely a problem with Inkodye, whereas lack of contrast between image and background caused by underexposure is more typical. Thirty minutes in *direct* sunlight is usually a minimum exposure time. Indoor exposure may take twice to three times as long, depending on the light source.

Developing the Image

After you remove fabric from the printing frame, store it overnight in a dark area until it is totally dry. The next day you can wash the fabric in a bath of warm water and mild soap. Full-cycle machine washing is recommended to remove all traces of the dye from the unexposed portions of the image area. Otherwise, the fabric should be hand-washed several times and rinsed thoroughly.

The Inkodye image is set permanently with heat. You can place the wet fabric in a dryer at the temperature setting suggested for that fabric, or you can line-dry the fabric and then set the dye by pressing with a hot iron.

Photo-Mordant Print

Natural plant dyes are neither light-sensitive nor color-fast, yet when they are combined with a chemical mordant, they can be used to create natural-colored photo images on fiber and fabrics. Mordants are chemicals that have the ability to unite with natural plant dyes to make them color-fast. Metallic salts—alum, tin, chrome, iron—are the most commonly used mordants for natural plant dyes. Of this group, only chrome, or potassium dichromate,* has a light-sensitivity level suited to contact printing film negatives on sensitized fabric.

Photo-mordant printing is a two-part process based on the light sensitivity of chrome. The fabric is first sensitized with a solution of potassium dichromate, dried, printed by exposure to light, and developed. The pale dichromate image is then simmered in a natural dye bath to achieve the final color. As the chromic acid of the mordant image oxidizes the organic compounds, the dye is held fast in the exposed portion of the fabric. The dye remains soluble in the unexposed areas and can be removed by washing.

Natural plant dyes can produce many different colors and subtle shades not attainable with commercial dyes. However, the use of a mordant to obtain a specific shade or dye color requires both knowledge of natural plant dyes and skill. The perfect mordant-dye combination for a fabric can be established through experimentation, but for the sake of simplification, only one mordant (chrome) and dye (onion skins) combination will be covered here. This proven combination will yield bronze-toned images on woolen fabrics.

PREPARATION FOR PRINTING

Fabric

Both 100-percent wool and cotton will accept dye, but color intensity will vary, making it necessary to test-dye before final dyeing is undertaken.

Wash fabric from newly spun wool yarn in mild soap until it is free of animal grease. Wash commercial cotton and wool fabric to remove all sizing prior to sensitizing. Prepare 2" × 4" test strips in the same manner as previously described and secure them to the larger sections of fabric with safety pins.

Materials for Dye Bath*

 stainless steel or enamel dye pot

 soft water (rain water)

 onion skins (brown exterior layer of skin, 4 ounces of skins per pound of fabric)

 glass or stainless steel stirring rod

* *Dichromate and bichromate are synonymous; labeling will depend on the chemical supplier. Check under both terms when ordering from a catalog.*

* *Although the dyeing process follows sensitizing, dye bath preparation should begin one day prior to use.*

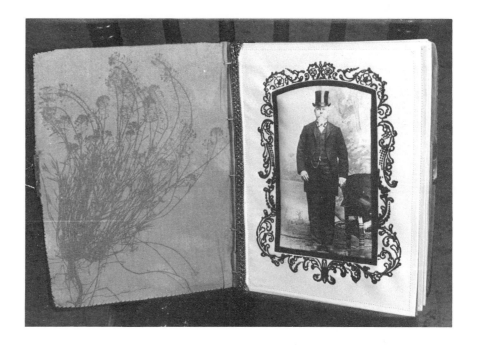

Photo Album. The rich gold print of wildflowers adorning the inside cover of the album was created by the photomordant process with natural onion skin dye. The black-and-white print on the right was printed on commercially sensitized photo linen. 9″ × 12″ × 2″. Artist, Cindy Sagen.

Prepare the dye bath by removing the brown outer layer of skins from the onion, crushing them, covering them with water, and soaking them overnight. The next day, boil this mixture for one-half to one hour and then strain and dilute it with soft water. The longer the mixture boils and the less it is diluted with soft water, the stronger the dye color will be.

The quantity of prepared dye bath depends on the amount of material to be dyed and the color strength desired. For example, 4 gallons of diluted dye bath will readily accommodate 1 pound of wool.

Materials for Sensitizing

potassium dichromate (Kodak product)*

brown bottle or jar (1-cup capacity)

gram scale (available in the dietary section of drug stores)

funnel

distilled water

darkroom graduate or liter measure

sensitizing tray

liquid starch

polyfoam brush (optional)

rubber gloves and protective clothing

paper cups and plastic spoons

newspapers

* *Potassium dichromate is a skin irritant with long-lasting effects. Once sensitivity is acquired, it can be permanent. Wear rubber gloves while mixing, applying, and developing this chemical.*

Mixing

Weigh out 58 g potassium dichromate and slowly add to 150 ml of hot (not boiling) distilled water. Stir constantly until all crystals are dissolved. Add distilled water to make 200 ml of liquid. When cool, the saturated solution will crystallize, and it will tend to deposit light-sensitive material unevenly. You can remedy this by mixing one part dichromate solution with one part liquid starch.

APPLICATION

The dichromate solution and starch mixture is practical for brush application. Place the fabric on a flat, plastic-lined surface, and brush the sensitizer evenly over its surface, first from side to side, and then from top to bottom, until it is entirely covered. Do not use starch if the fabric is to be immersed.

Large lengths of fabric may be sensitized in a water-diluted solution (one part original dichromate solution to one part water). In this case, fabric should soak in the solution for three to five minutes. Heating the solution slightly will facilitate the absorption of the sensitizer.

PRINTING

Exposing the Fabric

Dichromate is sensitive to ultraviolet light: carbon arc, sunlamp, photoflood, and direct sunlight. Exposure time will vary and should be determined with test strips. Exposure in direct sunlight will take about fifteen minutes. The process of contact printing is the same as the cyanotype process.

Developing the Image

Develop the image by washing it in a tray of running water that is flowing into the tray from a small hose. Do not direct the water's force onto the image area. Wash gently but thoroughly until all stain has been removed from the background of the print and the run off is clear. Place the washed print and test strips in a container of lukewarm water.

Dyeing

Heat the dye bath to a lukewarm temperature and place the wet printed material in the dye pot. It is important to keep the printed material in motion. Use the stirrer to lift and move the fabric around the dye pot, distributing the dye evenly throughout the piece. Then heat the dye bath to simmering and maintain it at an even temperature (do not boil) for one-half to one hour, or until you obtain the desired color. The image will appear much darker in the dye bath. Mordanted test strips can be removed, washed, and examined at timed intervals during the dyeing process to capture an exact color.

Rinsing and drying

Begin by rinsing the dyed print in a pail of hot water. Each successive rinse will be slightly cooler until all excess dye is washed away and only the dyed image remains. Then squeeze excess water from the fabric and hang the fabric away from direct light to dry.

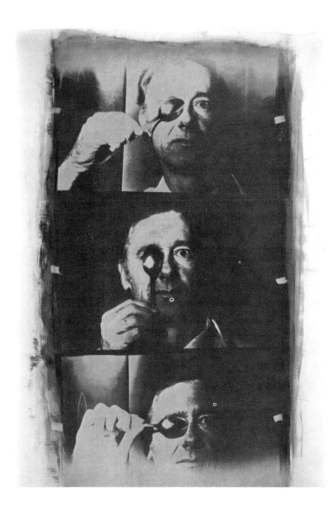

Demonstration of the Three Major Types of Corneal Toricity. Gum print on Rives BFK watercolor paper. 20½″ × 29½″. Artist, Ken Steuck.

Gum Printing

The gum-printing process was one of the earliest photographic processes to be used as a medium for personal expression. Its unique textural quality and full color range exhibited a painting-like beauty not present in the stark, more technically oriented photographs being displayed in photographic salons at the turn of the century. But with the talents of artist-photographers, such as the Frenchman, Robert Demachy, gum printing reached its peak in popularity during this period. Shortly thereafter, it fell into disuse, as more efficient processes were discovered.

Gum printing is based on the light sensitivity of potassium dichromate mixed with colloid gum that has been colored with a finely ground pigment, such as watercolor pigment. This method of printing is simple in theory but somewhat more complex in practice when used to create full-color images. A monochromatic print is created when light passes through a contact film negative and renders the gum sensitizer insoluble. Development occurs when the unexposed areas of color are washed away when soaked in plain water. This leaves only the exposed areas of the image to harden on the surface of the support.

left: Feathery images resembling watercolor paintings can be created by building up layers of pigmented gum on fabric. In this example, stitchery outlining was used to heighten form. 8" × 12". Artist, Richard B. Hubbard. (See color section.)

above: Canceled. Gum print on cotton mounted flat behind clear Plexiglas covering. 8½" × 11". Artist, Therese Weedy.

A print produced by printing several soft colors can resemble a pointillist painting, as seen in *Girl In Chair.* 4" × 5". Artist, Cynthia Lee Bowman.

When a full-color print is desired, the process must be repeated three times. Color-separated negatives are prepared as described in Chapter II. First the yellow layer of pigment is printed, developed, and dried. Next the red layer is applied, and finally the blue, using the same procedure. The results from this layering of pigmented gum can be used to produce delicate, feathery images resembling watercolor paintings. Although it is possible to print strong-contrast negatives, the medium is most expressive when normally developed negatives of paper-printing quality are selected.

PREPARATION FOR PRINTING

Work Area

A dimly lit or safelighted area is needed for mixing the two-part solution and for applying and drying the pigmented gum sensitizer. As with other processes, work areas must be adequately covered with newspaper or plastic that can be discarded after use. Materials needed for mixing the sensitizer and for its application should be assembled in the work area. A dark drying area equipped with clothesline, clothespins, and a protected floor surface should be provided for dyeing sensitized fabrics.

Fabric

Many types of fabrics—cotton, satin, acetate, linen, and some synthetics —will accept the gum sensitizer. The success of the finished piece will vary with the texture of the fabric, its surface preparation, the consistency of the sensitizer, and the quantity of the pigmented mixture. Unsized fabric that permits the sensitizer to be absorbed into the fibers will maintain its flexibility and texture. Conversely, fabrics that have been sized provide a stable surface for printing but require that the finished print be mounted flat.

When pliability and texture are major considerations, remove all sizing from the fabric. Thoroughly wash new fabric that has factory sizing, then press it to remove all wrinkles. You can then apply a liquid mixture of sensitizer to the fabric. A multicolored print that results from several layers of pigmented gum will change the surface of unsized fabric. When several colors are to be printed, you can remedy this by using a thin solution with a minimum quantity of watercolor pigment in each color layer to avoid a heavy buildup in the image area.

When less flexibility is required and the finished print is to be mounted flat, you can apply sizing to the fabric before it is sensitized. You can then apply a thick, emulsion-like mixture of sensitizer to the surface. Factory sizing in new fabric is usually not sufficient to support the thicker gum mixture and resizing is necessary. Methods for sizing are related to the fabric used. You can size cotton by evenly coating it with spray starch or by dipping it into a medium starch bath and ironing it while it is still damp. Other fabrics, which do not readily accept starch, can be precoated with a thin layer of gum solution (three or four parts water to one part gum). This establishes a uniform texture that allows the sensitizer to be spread evenly over the fabric.

If the surface appears wrinkled, the fabric must be pressed before sensitizing, since gum sensitizer is hardened by heat as well as light. Multiple test strips (2″ × 4″ strips of the sensitized fabric) will be necessary for each print to determine the ratio of pigment to gum and the correct exposure time for printing.

Materials for Sensitizing

chemicals: potassium or ammonium dichromate or bichromate (available from Kodak or chemical supply house)

color pigment: finely ground pigment such as used in tube watercolor is best (Winsor & Newton watercolor or Grumbacher Gouache colors work best; Prang poster colors will also work for high-contrast prints)

1 brown storage bottle or jar (1-pint or 500 ml capacity)

1 widemouth, capped jar (2-cup or 500 ml capacity)

gram scale (available in the dietary section of drug stores)

darkroom graduate or liter measure

distilled water (½ gallon or 1.9 l)

mixing container paper cups and plastic spoons

funnel polyfoam brush

rubber gloves and protective clothing newspapers

Gum solution A is prepared first and allowed to stand until completely dissolved (up to two days). Dichromate is then mixed with hot distilled water and funneled into a separate container.

Watercolor pigment is added to the gum before solution A and B are combined in equal parts to form the sensitizer.

Mixing

Solution A: Emulsion-type consistency (for sized fabrics)
60 g gum arabic dissolved in 120 ml distilled water

Liquid consistency (for unsized fabrics)
60 g gum arabic dissolved in 180 ml distilled water (add pigment to solution A just before combining it with solution B)

Solution B: 14 g potassium dichromate* dissolved in 150 ml hot distilled water

This saturated solution will crystalize when cold. If prepared prior to use, the solution must be warmed until the crystals dissolve. Solution B has a long shelf life when stored in a capped opaque container.

When multicolor prints are planned, it is advisable to mix a quantity of solution A for later use. Gum dissolves slowly and must be mixed with distilled water at least two days prior to use. You can store the gum solution in a tightly capped jar in the refrigerator for two or three days. You can greatly extend the storage life by adding a few drops of formaldehyde to prevent the growth of bacteria.

After the two basic solutions are prepared, add pigment to solution A only. Thoroughly mix tube watercolor pigment with the gum. The ratio of pigment to gum solution will vary with the color's intensity and the pigment brand. To test the printed color, begin with a small amount of gum solution and add pigment, then mix and combine it with equal parts of solution B. Paint, dry, and develop test strips. Keep a record of pigment ratios for all test strips. Generally, 5 g of pigment added to 60 ml gum solution will produce a strong color. You can obtain softer shades, usually desirable when multiple layers are planned, by adding a smaller amount of color to the gum.

After the pigment is completely dissolved in the gum solution, combine equal parts of A (gum and pigment) with B (potassium dichromate) to form the sensitizer. Once mixed, the sensitizer begins to harden even without the presence of light and should be applied and printed immediately upon drying. The combined solution cannot be stored.

APPLICATION

The technique for applying the gum sensitizer is important to the quality of the final print. Although some texture is desirable, even coverage is essential for the reproduction of a recognizable image. Methods of application will differ with the consistency of the sensitizer and the fabric treatment.

Method I

Fabrics with a sized surface must be held taut while the emulsion-type sensitizer is being applied. A drawing board or piece of flat plywood lined with a protective covering of plastic provides a good surface for securing the fabric with thumbtacks or pushpins. Saturate a polyfoam brush with sensitizer and brush from the top to the bottom of the fabric. If heavy brush strokes are visible, you can remove them by brushing lightly in the

* Potassium dichromate (bichromate) is poisonous and a skin irritant with long-lasting sensitivity. Wear rubber gloves while mixing, applying, and developing with this chemical.

opposite direction from right to left. However, overbrushing causes the sensitizer to set too rapidly. Apply the emulsion as quickly and evenly as possible. You can incorporate brush marks around the edges of the fabric into the image design or completely eliminate them by brushing over edges onto the plastic lining. Then hang the coated fabric to dry in the dark. Drying can be hastened with a fan, but heat cannot be used.

Method II

Apply a thinner gum sensitizer, much the same as the liquid sensitizing solutions. A flat pan or smooth developing tray provides a good coating surface. Place several layers of fabric in the tray for consecutive coating. You can tape small pieces of fabric to the tray. Use the polyfoam brush to coat the first piece evenly, remove it, and hang it to dry in a dark area away from direct heat. The second layer, which acts as a blotter for the first layer, receives the excess sensitizer. It, too, can then be fully coated, and so on.

PRINTING

Materials

Gum-sensitized fabric is contact-printed with ultraviolet light. A mercury lamp is a preferred light source; however, you can use direct sunlight, a sunlamp, or even a two-tube fluorescent desk lamp to expose the prints.

The full-sized negative prepared for contact printing should exhibit average or below-average tonal range. Use negative images that will benefit from the softening of outline and detail produced by gum printing.

Exposing the Fabric

Exposure time for gum printing is relatively short. A five- to ten-minute exposure in direct sunlight or under a sunlamp can be sufficient, whereas mercury lamp exposure may be even shorter. Exposures using double fluorescent tubes at a distance of 12 inches often require up to half an hour. After the negative is contact-printed, a faint image will appear on the exposed fabric, but this is not a "readable" indication of exposure time.

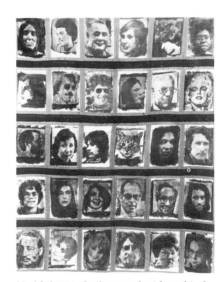

Untitled 1974. Quilt created with multicolored gum-printed images on muslin and cotton. Hand and machine stitching. 98" × 72". Artist, Risa Goldman. Photograph courtesy of the American Crafts Council's Museum of Contemporary Crafts.

Test strips cannot be processed in the manner described for previous sensitizers, since gum development will take from fifteen minutes to an hour. Conduct exposure tests prior to printing the fabric, developing each strip at three-minute intervals for a projected ten-minute exposure. You can reduce overexposed strips by extending the development, whereas underexposed strips will remain shallow. Run test exposures for each color printed, since exposure time will vary with the pigment used.

Developing the Image

Develop gum prints in plain water at about 80°F. Fill a deep pan or developing tray, which will enable the fabric to float flat, with warm water just prior to development (do not pour water directly on the print). Develop the fabric immediately after exposure to prevent further hardening of the gum. Development can take place in a normally lighted room.

First submerge the entire piece of fabric in the tray of water, image side

up, until it is fully saturated. Then lift it gently by one edge and place it face down in the water to develop. The developing gum print is fragile and must be treated gently. Unnecessary movement or rocking of the tray during development may cause the gum image to disintegrate.

As the print develops, traces of pigment become evident in the water. Dissolved pigment may cause staining, especially when dark tones are used, making it necessary to remove the print from the polluted water after about fifteen minutes. Continue development by placing the print in a fresh tray of warm water.

The development of a gum print cannot be equated with other types of photographic development. The quality of the original negative does not necessarily limit the depth of the image. Even very thin negatives can produce excellent results when the print is removed from the water at the optimum moment. In this sense, the development of the print is an aesthetic as well as technical decision.

Technically, the print can be removed from the water when the yellow dichromate stain has disappeared from the back of the fabric. Total development should take approximately an hour. During this time, you can lighten the image by using a soft brush to remove areas of pigmented gum. Continued development will reduce the image; an overexposed print can remain submerged in water for five to six hours.

The printed gum surface is delicate when wet and cannot be twisted or wrung. Place the wet fabric on a flat surface to "set" before hanging the fabric to dry.

After drying, you can observe the final color of the print. When the print color appears dull, recoat and reprint it to deepen the original tonal value. You can obtain richness and color depth by using the same color to print numerous layers of pigmented gum, each one perfectly registered with the previously printed image.

MULTICOLOR PRINTS

Creating full-color images with a contact-speed sensitizer is one of the unique options of the gum-printing process. Because the pigmented layers of sensitized gum are printed and developed independently, complete control can be exercised over the image. Used skillfully, this process permits the production of a print with highly individualized color, or a naturalistic rendering of a color transparency.

When you want to obtain natural colors, first make a color separation from the original transparency (see Chapter II). In this case, a color separation should result in three full-sized negatives, one for each primary color. Then print the negatives in a prescribed color sequence with the lightest color, yellow, printed first. Next, print magenta over the yellow, followed by blue in the final layer. The negative must be perfectly registered in each successive printing, so doublecheck the registration before you undertake the three-color printing.

Arbitrary use of color is more free-wheeling with emphasis placed on personal expression. You can build up portions of the image area in a second color after the overall image has been established with the first layer of thinly pigmented gum. You can add numerous layers to cover the basic color totally or partially.

You can select sections of the original negative for a second printing, or contact-print a full-sized positive from the original negative when you plan a two-color print. You can accomplish more complex layering by making several negatives and/or positives with varying tonal value. Print the lightest color first, then each additional layer until you obtain the desired depth and tonal range.

Clearing

The print will sometimes require stain removal (clearing) when a background color remains. You can remove stains and/or an overall background tint by soaking the print in a 5-percent solution of potassium alum and distilled water. Undertake clearing only when absolutely necessary, since the alum solution lessens the delicate quality of the original print.

Kwik-Print

Kwik-Print is a prepackaged sensitizer originally manufactured to provide a color proofing method for commercial artists to evaluate color layouts prior to full-color printing. Used as a fabric sensitizer, however, Kwik-Print provides a good means of obtaining gumlike prints without necessitating the mixing of chemical solutions.

Kwik-Print is available in fourteen colors and Clear. You can mix with Kwik-Print colors to reduce their intensity, an important feature when sensitizing fabrics. You can add one part Clear to one part Kwik-Print color to prevent background tinting when dark tones are printed. In addition, Kwik-Print Clear combines with watercolor pigments to produce color prints that are equivalent to those made with pigmented gum.

Apply Kwik-Print to synthetic fabrics using techniques similar to those suggested for gum printing. However, you must apply the darkest color *first* when you print color-separated negatives.

Kwik-Print has a shelf-life of several months. The expiration date is noted on each container.

PREPARATION FOR PRINTING

Work Area

Work in a well-ventilated, dimly-lit area similar to that used for gum printing.

This series from *Komoi Freize* is an example of high-contrast images printed on Kwik-Print-sensitized cotton. The individual images were then quilted and hand colored with dye crayon. 60″ × 12″. Artist, James H. Sanders III.

Fabric

Many types of synthetic fabric work well with Kwik-Print. Acetate, nylon, polyester, and the like can be sensitized, but you should make test strips to obtain performance data for specific fabrics. When you use natural fabrics, first size them with a coating of spray starch and iron them.

Materials for Sensitizing and Application

Kwik-Print colors, or Kwik-Print Clear plus watercolor pigments
rubber gloves and protective clothing
polyfoam brush or medium-size (2"–3") bristle brush
application tray
tape
newspapers

APPLICATION

Fabric is taped to a developing tray and sensitized with an even coating of Kwik-Print applied with a polyfoam brush.

Kwik-Print is a dense liquid with a paintlike consistency. Brush the sensitizer onto the surface of the fabric to provide a smooth image area. You can use an airbrush when very even application is essential to the work. Smooth application is not vital to the process, however, since brush strokes can enhance the print's textural quality.

You can achieve a comparatively smooth coating by applying the sensitizer with a wide polyfoam brush, using even strokes from the top to the bottom of the fabric. You can then remove any excess that might cause streaking by brushing lightly from side to side.

Whatever the tool used for application, the freshly pressed fabric must be secure to prevent wrinkling. As in gum application, you can tack the fabric to a board or tape it to a developing tray with a layer of absorbent fabric placed underneath to act as a blotter. After the fabric is sensitized, hang it or lay it flat to dry in a light-safe area away from direct heat. As with sensitized gum, immediate printing after drying will ensure the greatest degree of sensitivity and prevent background tinting in the final print.

PRINTING

Materials

Contact-print the Kwik-Print image according to instructions accompanying the products. A photoflood, sunlamp, direct sunlight, or other ultraviolet light sources can be used. The enlarged negative may range from high contrast to the normal density used for paper prints.

Developing the Image

After exposure, develop the Kwik-Print image immediately with a strong spray of water to remove pigmented sensitizer from the unexposed areas of the print. The image should be fully visible at this stage. Next, bathe the print in a weak solution (15 ml aqua ammonia to 3.8 l water) of ammoniated water for five to ten seconds to help clear the background tint. Spray the print again with plain water to rinse out the ammonia and clear the image of any remaining pigment. After the final rinse, place the

printed fabric flat on a fabric or paper blotter to remove excess water before you hang it to dry.

Clearing

When background tint persists, you can clear the image with Kwik-Print Brightener. Instructions for its use are supplied with the product.

Other Sensitizing Processes for Fabrics

The following processes are additional methods by which fabric may be sensitized and printed with photographic images. They have not been covered in this text because of their complexity in preparation or their chemical hazards. For more information about these processes, see the Bibliography for this chapter.

KALLITYPE PRINT

The kallitype process is a silver nitrate-based sensitizer similar to the Vandyke in color. However, the process is more complex and is used when better control of both tone and contrast is required. The basic formula contains ferric oxalate, oxalic acid, and silver nitrate in a solution of distilled water. Various formulas can be used to develop the image, depending on the final color desired.

PLATINUM PRINT

The platinum process is a multistep procedure based on the principle that platinum links with photosensitive iron salts. After development, the less stable iron is etched away, leaving only the permanent platinum image. The high-quality print attainable from this process ranges in color from brown-black to gray-black, depending on the development.

DIAZOTYPE PRINT

The diazotype image is a product of dye-forming compounds that decompose when exposed to light. The image is produced only in areas not exposed to light. A film positive is required to print a positive image. The exposed image is then developed in a chemical solution to produce the desired dye color.

(a) *Private Thoughts as Public Events: Painted Lady and Her Children.* Xerox image printed with Kwik-Print with stenciled lettering on stitched and stuffed fabric. 16½" × 23". Artist, M. Joan Lintault. (b) Detail.

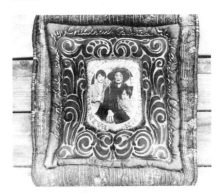

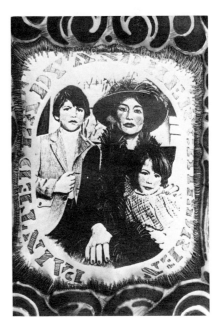

V

Emulsion-Printing Processes

The Zoo. A series of emulsion-printed images on watercolor paper. 20″ × 30″ overall. Artist, Jeanne Morley. (b) Detail, 8″ × 6″.

The Projection Print

In general terms, the word "emulsion" is used to describe any suspension of fine particles in a liquid. However, for the sake of clarity in this text, an emulsion is defined as a compound of silver salts suspended in a gelatin binder. The gelatin allows many light-sensitive particles to be packed into a small area. The resulting emulsion works much more quickly and more efficiently than contact-speed sensitizers contained in liquid solutions.

Projection-speed emulsions, as the name implies, are printed with a darkroom enlarger. Small negatives can be projected to create an image directly onto an emulsion-coated surface. After exposure, the image is processed in the same manner as photo papers: developed, stopped, and fixed.

Although a darkroom setup with an enlarger is necessary for projection printing, emulsion-coated surfaces can also be contact-printed under safelight conditions in any work area. This procedure takes only a few seconds of exposure time, compared with several minutes required to contact-print with a slow-speed sensitizer.

Until recently, artists wishing to print photos by projection onto non-paper surfaces were faced with creating their own photographic emulsion. Although this is not impossible, it does require a high degree of control and precise chemical formulation. Fortunately, homemade emulsions are no longer a necessity, as several manufacturers specialize in emulsions formulated for direct application onto a variety of surfaces. However, if you are interested in creating your own emulsion, you may do so by following the complete instructions provided in *Pamphlet AJ-12*, published by Eastman Kodak Company.

Emulsion Prints on Fabric and Paper

Emulsions tend to stiffen the texture of the material to which they are applied. Paper will not be greatly affected, but fabric will become less pliable and the final print will remain vulnerable to surface scratching and abrasion.

DESIGN

Spreading emulsions are versatile for printing photos on a variety of fabric and paper surfaces. Because the emulsion is applied directly to the support, the final print's textural quality is modified by the choice of materials as well as the type of application. A paintlike quality is created when the emulsion is applied with bold, uneven brush strokes. The resulting print exhibits a style indicative of the process, which cannot be obtained with presensitized products.

The emotional portrayal of *Next Morning*, a photo printed on emulsion-coated paper, was achieved with an intentional unevenness of application. The texture of the image successfully reinforces the mood depicted in the photograph. This type of application, however, is effective only when the subject matter is substantiated. In many cases, the photo image will require a more straightforward reproduction, with the support furnishing a textural background for the print. In the composition, *Theater Windows and Stretcher Bars*, Ellen Reilly has maintained the texture of the underlying fabric without sacrificing the pictorial character of the photos. She achieved this by applying an even coating of emulsion to raw canvas.

When an even, predictable printing surface is imperative to the work, a commercially sensitized fabric, called photo linen, can be used. This product, not to be confused with the textured paper called photo linen, is not distributed by local photo shops; it must be purchased directly from the manufacturer. (See supplier's list in the back of the book.)

One of the greatest advantages of spreadable photo emulsion is that it can be controlled and positioned anywhere on a surface, adhering to a defined area without spreading. The soft sculpture, *Self Portrait* illustrates this selective printing. The stitched and stuffed fabric form acts as an environment and adds depth to the photo.

Multiple photo images can be printed on emulsion-coated fabric and paper by means of the techniques used for printing a photomontage. An area of the photosensitive surface is masked while another is printed, and the procedure is reversed until all images in the composite print have been exposed.

In the print *Theater Windows, Stretcher Bars*, the textural quality of the underlying canvas is maintained without sacrificing the image. 8″ × 41″. Artist, Ellen Reilly. (b) Detail.

The illusionary view seen from the *Window* was printed on presensitized photo linen. Artist, Cindy Sagen.

An entirely different type of composition is possible when photos are printed on separate pieces of fabric or paper and then assembled into a collage. Individual prints, or cut sections of prints, are easily combined by stitching or gluing. Once the underlying order of the work has been established, the prints lose their separate identities by merging into the total statement. Although the photos in *Route 9A* have a subjective rather than an actual pictorial relationship, the separate prints achieve continuity through a rhythm of dark and light forms that flow through the individual photos—as if the viewer were actually watching scenes from a moving vehicle. (See page 124.)

Like other types of photos, prints on emulsion-coated fabric or paper can be embellished or hand-colored. Hand-colored photo images need not adhere to a realistic scheme but can be arbitrarily colored with a variety of substances. Photo dyes, thinned acrylic or oil paint, colored pencils, marking pens, pastels, or even stitchery might be used after some prior testing has proved their suitability. Photo surfaces to be stitched or embroidered should be covered with a sheet of thin tracing paper to protect the image surface while work progresses. The paper is later cut or pulled away from the stitched areas, leaving the embellishment on the face of the print.

PREPARATION FOR PRINTING

Work Area and Materials

A fully equipped darkroom with standard trays and an amber or red safelight is required for printing projection-speed emulsion. Utensils that will contact the corrosive emulsion should be made of glass, hard plastic, or stainless steel. A deep bowl filled with hot water is needed for warming the emulsion. A darkroom thermometer is used to check the water temperature before and during the time that the emulsion is being liquefied.

As a rule, emulsion is absorbed easily into the surface of porous papers, whereas treated fabrics require a thorough washing to rid them of chemicals and sizing before the emulsion can be applied. Once the fabric is free of sizing, the emulsion flows between the woven fibers, forming a bond with the fabric. Precoated fabric, such as primed artist's canvas, will not hold the emulsion properly and must be recoated with a thin layer of gesso to provide "tooth" for good adhesion. The label on the emulsion package will suggest surfaces on which the emulsion can be used most successfully.

Chemicals required for processing exposed emulsion surfaces are the same as common developer, stop, and fixer recommended for photo papers. More specific information about those chemical solutions will be provided in the instruction sheet accompanying the emulsion.*

APPLICATION

Before the emulsion can be applied, the support must be prepared. Single pieces of fabric or paper may be taped to a protected tabletop. When

A satin form with machine stitching acts as an environment for the emulsion print *Self Portrait.* 32″ × 24″. Artist, Barbara Boeing.

* *Commercially produced emulsion often contains phenol (poison) as a preservative. Phenol vapors are harmful; all work should be conducted in a well-ventilated area.*

several pieces of porous fabric are to be coated at one time, the fabric is stacked in layers. As the first layer is coated, excess emulsion seeps through the fabric, helping it sensitize the second layer, and so on. Large sections of fabric can be mounted on canvas stretchers to hold the surface taut for easier coating.

After the support has been prepared, all room lights, except the safelight, are turned off. The container is placed into a bowl of hot water to liquefy the emulsion. The emulsion will flow at about 95°F to 105°F. This temperature should not be exceeded since overheating can fog the print. When only a portion of the emulsion is needed, it should be heated only until that amount becomes liquefied. The emulsion will resolidify quickly, so it should be applied immediately.

Which type of application to use will depend on the texture desired in the final print. A coarse texture will result if the emulsion is brushed on with a large-bristled brush. Application with a polyfoam brush will produce a smoother printing surface. An almost flawless surface will result if the thinned emulsion is spray-coated with an aerosol unit or airgun. Spray-coating may require more than one application to build an evenly sensitized surface. When large areas of fabric or paper are to be covered, or when an emulsion is to be sprayed, you can thin the emulsion by adding up to 20-percent warm water to help maintain its liquid state during application.

You can coat heavily bodied, stiff supports by pouring the liquid emulsion directly onto the fabric or paper. Once the coat of emulsion has leveled, any excess should be funneled back into the opaque bottle.

Coat 2″ × 6″ test strips at the same time as the primary surface is coated. Two or more test strips should be sensitized for each print planned.

Surface Studies—Part One: Variations on a Theme of Wallpaper. A composition printed on emulsion-coated Arches paper and hand-tinted with colored pencils. 17″ × 10″. Artist, Elisa Tenebaum.

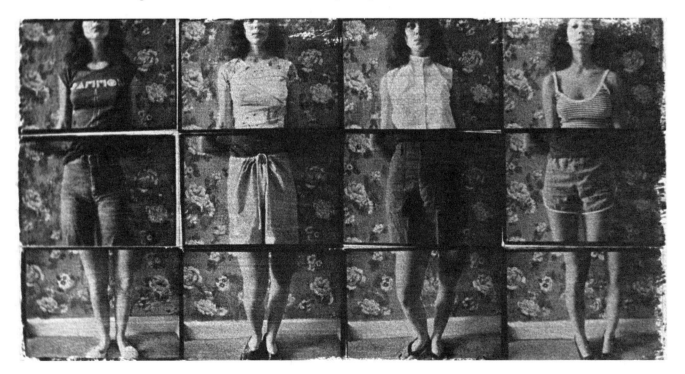

PRINTING

Exposing and Processing the Print

After the emulsion is completely dry, the photosensitive surface is equivalent to a sheet of average-speed photographic paper. You can determine the initial exposure time by making test enlargements on paper. Then you can evaluate the exposure time and lens setting by printing an emulsion-coated test strip.

The test strip is processed by the same method planned for the actual enlargement. When the standard processing procedure is used, the test strip is submerged in trays filled with chemical solutions that do not exceed room temperature (65°F to 68°F). If a print is oversized and too large for submersion in a developing tray, a wide, plastic-lined countertop or table can be used for sponge processing: The surface of the print is gently wiped using three separate sponges that have been saturated with the three separate chemical solutions.

Following a successful test, you can begin actual exposure. Often an adjustable easel for photo paper can be used to hold the emulsion-coated material. For an odd-shaped print area, the paper or fabric is taped directly to the enlarger base.

Extremely large pieces mounted on canvas stretchers cannot be exposed in the usual manner. You should check the enlarger manual for instructions for projecting an image of the required size onto the wall or floor. Using the red enlarger filter to cover the lens, you can focus the image directly onto the sensitized material without exposing it. Exposure and processing then proceed according to the test strip data.

Finally, the print is washed gently in cool water for approximately half an hour, depending on the size of the piece and the porosity of the support material.

Emulsion Prints on Ceramic, Glass, Metal, Plastic, and Enamel Surfaces

Photo emulsions can be applied and photos printed on almost any material after the surface has been properly prepared.

Kiln-fired photo images on ceramics were being produced as early as the 1850s, but, like many early processes, fell into disuse once prepackaged chemicals and photo papers became available. Today, the process has been revived by artists who are testing the original formulas to arrive at the pictorial quality desired in their work. This technique requires several additional steps to chemically pigment the silver image, enabling it to withstand the firing process. A kit for general use is now available that contains premeasured chemicals and step-by-step instructions.

Another product, presensitized aluminum, now makes it possible to print photos directly on metal without surface preparation or emulsion application. The photosensitive sheets of aluminum, available in various sizes (.016″ thick), provide a printing surface equivalent to that of an average photographic paper.

The image of the human figure works harmoniously with the shape of the sculpture, appearing to be a formation found in the heart of the clay. *Untitled* contains a fired-emulsion image. 13″ × 7″ × 5¾″. Artist, John C. Barsness.

DESIGN

Photos projected on three-dimensional surfaces often are distorted by the underlying shape. This is a design problem that must be investigated well in advance of printing. The photo should first be projected with an enlarger onto the proposed printing area to determine its suitability to the design. Surfaces with extreme curvature will cause light and the image from the enlarger to be dissipated. This distortion can add to the interest of a composition in some cases, but in other instances the image will become unrecognizable.

Because emulsion printing is basically a black-and-white process, color is not a variable. The translucent image derived from firing a photo onto a glazed ceramic surface is an exception because underglazes will show through the image and add color. Photo ceramics can also be colored after firing by the application of lusters, which are then refired at a lower temperature.

PREPARATION FOR PRINTING

Materials

Although almost all emulsions are suitable for ceramic surfaces, the resulting print cannot be fired. For this special application, a kit containing the emulsion and pigmenting chemicals will be needed.

A photo image to be fired can be printed over any ceramic glaze, as long as the underlying glaze is light enough not to obscure the image. Some basic glaze colors that might be used are high-gloss or satin matte white, off-white, and light yellow.

Although the surfaces on which the emulsion may be applied vary greatly, shapes most likely to carry a print without distortion are flat, or only slightly concave or convex.

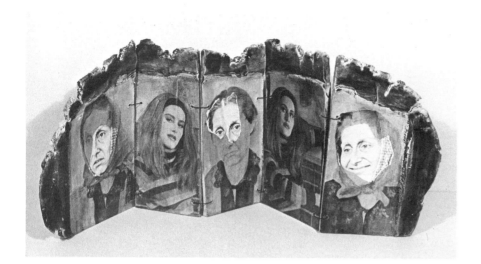

Before and After #3 was created on a bisque-fired, white earthenware body sensitized with emulsion. After printing, the images were hand-colored or stained with acrylics, watercolor, and inks. 26″ × 10″ × 8″. Artist, Mary Ann Johns.

Surface Preparation

Meticulous surface preparation is vital to success, since a tiny spot of dirt or grease can cause the emulsion to flake or peel during processing. Glass and ceramic surfaces are washed thoroughly with hot water containing washing or sal soda. When ceramic pieces are to be fired, a diluted solution of one part household bleach to ten parts water is recommended for the initial surface cleaning. After it is cleaned, the surface cannot be touched with the fingers and should be dried immediately with a small fan.

The next procedure, called subbing, is necessary to clean ceramics and glass further prior to emulsion application. The subbing solution (which is a chemical cleaner, so rubber gloves should be worn) is mixed as directed by the supplier of the emulsion. This solution is poured over the surface and again dried by a fan.

Glossy metal, plastic, or enameled surfaces are painted with a primer coat of polyurethane or bakelite (clear finish) diluted 1:1 with mineral spirits of turpentine. This undercoating is applied and dried at least twelve hours before the emulsion coating is applied. High-gloss surfaces may fail to form a permanent bond with the primer coat unless the surface is roughed with fine-grade steel wool.

APPLICATION

The emulsion is applied and printed, using only a safelight, as recommended in the manufacturer's instruction sheet.

Unlike porous paper and fabric, slick surfaces require an even coating of emulsion for proper adhesion. The emulsion will adhere best to warm surfaces, and pieces can be heated slightly (not over 100°F) before the first application.

Usually, the best coating technique is to pour the warm, liquefied emulsion onto the material and spread it by tilting the surface, distributing the emulsion evenly. Once the surface is fully coated, the excess can be poured off and saved.

Uneven surfaces that do not lend themselves to this method can be

spray-coated with an airgun or aerosol unit. The emulsion is diluted with warm water per the manufacturer's instructions. After the first thin spray coating has dried, a second coat is applied to assure even distribution.

PRINTING

The equipment, materials, and processes are the same as those for printing a regular emulsion.

The emulsion supplied in the photo ceramic kit is comparable to a #5 contrast-grade enlargement with a very narrow gray scale. Even so, thin negatives will not reproduce well, so only quality images should be considered for this process. Exposure time is not critical when photo ceramic emulsion is printed. It ranges from twenty to sixty seconds at f8 lens operating without appreciable differences in the results.

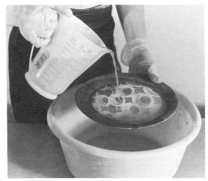

To pigment the print, pour the pigmenting solution over the image continually for five minutes.

Prefiring Processes for Photo Ceramics

After the emulsion-printed image is processed in the usual manner, the ceramic piece must undergo additional chemical treatment before firing. It may be treated immediately, or the fixed and washed piece may be pigmented later, when several pieces can be prepared for firing.

After the image has been fixed, the additional processes are performed in normal light. Because the kit chemical is toxic and can be absorbed through the skin, rubber gloves are needed throughout the pigmenting and stabilizing processes. Chemical solutions must be mixed fresh, per kit instructions, and used immediately for good results.

During pigmentation, the photo attracts a pigment from the solution of cobalt chloride and potassium dichromate, coloring the silver image to the same density as the original print. The pigmenting solution is poured repeatedly over the image for at least five minutes. Theoretically, extending this procedure will deepen the contrast; the solution may be poured or agitated over the print surface for up to thirty minutes.

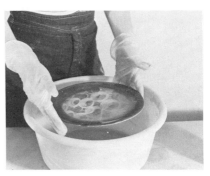

During stabilization, agitate the solution over the printed surface for only thirty seconds, then allow it to soak.

After pigmenting, the image is stabilized in a two-part solution of lead nitrate and potassium dichromate for ten minutes. During the first thirty seconds, the stabilizing solution is poured or agitated, with the remaining time used to soak the image. Following this, the piece is washed for five minutes and allowed to dry. Once the print is dry, it can be evaluated. If necessary, any or all of the image can be wiped off with a cloth saturated with household bleach and water. If the print is satisfactory, the piece is ready for firing.

Firing Photo Ceramics

The glaze used in the original firing will help determine the firing temperature. A fast cycle usually produces the best image. Cone 016 should be reached in about three hours; the kiln is then turned off and allowed to cool. The fired image should appear uniformly glossy. Dull areas indicate underfiring that can be corrected by refiring. A surface marred with tiny bubbles indicates overfiring and cannot be remedied. Firing to cone 5 will burn off the image completely.

A piece that is correctly fired can be handled like any overglaze. It may be considered complete or may be refired several times with lower-temperature lusters.

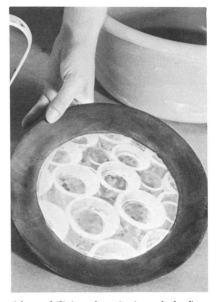

After stabilizing, the print is ready for firing. The plate, created by Lynn Eder, contains the image of drain tiles rimmed with a dark border of iron oxide.

Projection-speed Silkscreen Emulsion

For many years, photo silkscreens have been the most widely used method for printing on nonpaper surfaces. Once the photo stencil is applied to a silkscreen, a great many prints can be produced from the original. Color reproductions are made from a series of color-separated screens, each one in a primary color, printed in sequence.

Photo stencils for silkscreen printing are created by three different methods. The original process, still in use today, is based on a photosensitive bichromate mixture. This inexpensive mixture is created from one package (15 g) of plain gelatin dissolved in 60 ml water. After the gelatin has absorbed the water, the container holding the mixture is placed in warm water until the gelatin becomes fluid. At this point, 1 g ammonium dichromate crystals is added. The light-sensitive solution is immediately coated on the fabric of the screen. Upon drying, the bichromate-coated screen is exposed to light (photoflood) in contact with an enlarged positive film. Exposed areas become insoluble to form the stencil image, and unexposed areas are washed away.

Another, more contemporary, process requires photo stencil film (such as Ulano) especially created for this purpose. In this indirect method, the photo stencil film is printed in contact with a positive film enlargement, processed, and then adhered to the silkscreen. Only oil-based inks may be used with this type of stencil.

The lesser known third process uses a stencil produced directly on an emulsion-sensitized screen from a direct projection enlargement of a small-format positive film. Water-base ink will not dissolve the emulsion. Either oil- or water-base inks can be used for printing.

Photo silkscreen decals allow photo images to be placed on irregular surfaces impractical for direct printing. This full-sized ceramic sculpture of junk food was created in one unit and completed with fired photo decals. Artist, Victor D. Spinski.

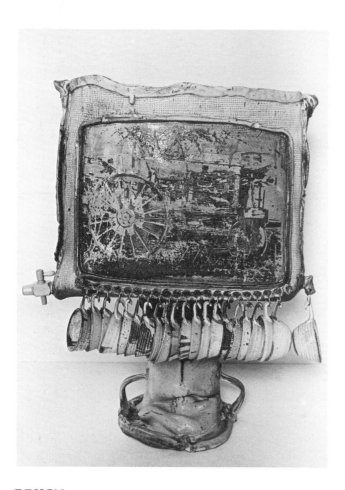

A photo silkscreen print of an antique farm machine was printed directly on clay to augment the machine's primitive appearance. 20 inches wide. Artist, Marvin Bartel. Photograph by Lenny Jordon.

DESIGN

Photo reproduction of any image is possible with any of the three silkscreen processes. However, the sharp, crisp lines in *Rock City Baroque* were attainable because of the precise reproduction capabilities of an indirect stencil film such as Ulano Hi-Fi Green or Blue Polly. With an emphasis on line and pattern, the composition was built around the interaction of negative and positive space. The picture of the barn is secondary to the pattern it creates.

A photo silkscreen image printed from an emulsion-coated screen is typically more "expressive." You can rely on a 35mm positive with excellent contrast to reproduce with good fidelity, but you can never expect it to match the reproduction quality of an enlarged halftone positive contacted onto stencil film.

Silkscreen processes and the material receiving the print must be chosen to complement one another. In a silkscreen print of an antique farm machine, Marvin Bartel used the underlying clay of the ceramic piece to augment the machine's appearance. The photo relates as an essential element working in harmony with the functional ceramic construction.

The relationship of texture to photo is also apparent in the silkscreen image of a skull printed on handmade paper. The print's fascination is derived from the transitory state it suggests. Without being pictorially

Detail, *Rock City Baroque*, a photo silkscreen print on linen. Artist, Richard Daehnert.

To coat a large silkscreen area with emulsion: (a) Pour liquefied emulsion along the inside of the silkscreen frame. (b) With one sweeping motion, pull the emulsion upward to coat the working section of the screen.

explicit, the skull fragment is visually associated with the heart images, evoking an emotional rather than intellectual response. The mystery of the imagery is due in part to the artist's unorthodox use of the medium.

PREPARATION FOR PRINTING

Work Area and Materials

Although the term "silkscreen" still persists, Dacron, nylon, and other synthetic fabrics are now more frequently used for screens. A well-constructed screen will make thousands of prints once the fabric has been stretched taut and secured over a wooden or metal frame. However, when a screen has been previously printed with oil-base inks, the fabric must be degreased with a hot washing solution of trisodium phosphate before the emulsion is applied.

To silkscreen-print a photo positive, you need a small-format positive film to project a negative image onto the emulsion-coated screen. You can create a small-format film positive by contact-printing a black-and-white negative onto ortho film. Alternatively, you can use a color transparency (slide film) if it contains cool tones that will reproduce well in a black-and-white enlargement.

Projection-speed emulsions must be applied in a safelighted darkroom. The enlarger must be adjusted to print sensitized screens. Its head may be positioned to project images onto a large sensitized silkscreen placed on the floor or affixed to the wall.

The processing area should be set up to accommodate the screen size. A table or countertop covered with plastic can be arranged for sponge development if the regular developing trays prove too small for submerging the screen.

Projection-speed silkscreen emulsion can be purchased in a kit that contains the necessary chemicals for developing the image. A squeegee is needed for coating the emulsion onto the screen. After development, a large sink or tub with warm running water must be provided to "wash out" the screen.

APPLICATION

Liquefy the emulsion to a coating temperature of 90°F to 95°F by submerging the container in a bowl of warm water. Then apply it in a well-ventilated, safelighted area.

When the screen is relatively small, you can best accomplish this procedure by placing the screen flat, bottom side up, on a plastic-covered surface. Pour a ribbon of emulsion along one side of the screen and then pull evenly across with the squeegee. Larger screens are coated standing up, bottom side out. The emulsion is poured onto the lower edge of the frame and pulled upward to coat the working portion of the screen. This should be done with one stroke, since pulling the emulsion back and forth causes uneven distribution. After coating, stand the wet screen on end and let it dry in total darkness. A fan may be used to speed the drying process, but note that heated air could ruin the emulsion.

PRINTING

Exposing the Print

Expose the emulsion-coated silkscreen with a positive film in the enlarger. (It can also be exposed by direct contact printing, as per kit instructions.) The procedure for direct enlargement onto emulsion is described earlier in this chapter. However, test strips are not practical when you use silkscreen emulsion.

You can estimate the exposure time by first making an exposure on regular bromide paper and multiplying this time factor by four. Although the paper may be as sensitive as the emulsion, it will take longer for the light to pass through the thick emulsion coating on the screen. An average exposure time might be one minute at a lens setting of f8. You can expose the screen from either side, depending on how the image is to appear in the final print. Place a sheet of black paper under the screen to prevent the light from reflecting back onto the underside of the screen during exposure.

Developing the Image

Dissolve the dry chemical in cool water, as per kit instructions. The temperature of the developer cannot exceed 68°F.

Develop large screens with a soft brush or sponge saturated with developer. Paint the developer on both sides of the emulsion-coated screen for two to three minutes. Smaller screens, placed in a tray of developer, should be agitated frequently during the three- to five-minute development period. Do not exceed these suggested times, since long development will cause the emulsion to harden and make it very difficult to remove.

When warm running water is available in the darkroom, you can wash out the developed screen directly with a gentle flow of warm (not hot) water to remove the unexposed portion of the image. If you must wash the screen in regular light outside the darkroom, fix the image with a 1:2 solution of white vinegar and water before washing it.

Once wash out is complete, use cool water for a final rinse, and then blot the screen dry with paper towels. If close inspection reveals a scum resi-

With the screen resting in a processing tray, sponge the developer over the exposed portion of the screen.

Wash the unexposed portion of the image from the screen with a gentle flow of warm water.

due in the open areas of the image on the screen, you can use a mixture of 30 ml liquid household bleach and 1 l water to clear the scum from the screen. Apply the solution only in the problem areas and wash it away after one or two minutes. Rinse the screen thoroughly, and then blot it dry. Once the emulsion is completely dry, block out open areas of the screen bordering the image. The type of temporary blockout used will depend on the type of silkscreen ink. Printing inks and blockout products are available in local art supply stores or from their manufacturers.

You can squeegee silkscreen inks as well as other liquid printing media through the screen according to the underlying material and the final application of the print. You can also produce photo images on enamels with a photo stencil. First, coat metal with enamel and fire it in the usual manner. Then screen the image onto the enameled surface using transparent silkscreen base. Dust a contrasting color of enamel over the image; it will adhere only to the moist base. Again, kiln-fire the enamel containing the image to produce the completed photo enamel.

(a) The artist created *Gail Twice*, a photo-enameled image, by silkscreening transparent base through the photo stencil and then dusting the printed surface with enamel. Each panel is 4½″ × 4¼″. Artist, Mel Someroski. Photograph by Greg Moore. (b) Completed work in frame, 9½″ × 8½″.

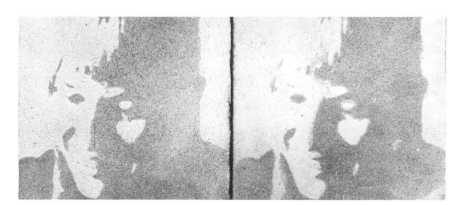

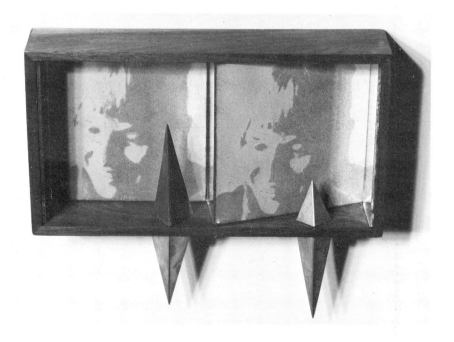

VI

Innovative Printing Processes

Methods explored in this chapter are as varied as the artists whose works are depicted, but they all share the sequence of experimenting, changing, reworking, and finally mastering materials and techniques.

As the work illustrated confirms, an artist must be successful on many levels, whether a photo image is printed on fabric or paper, used in combination with painting or drawing, or created from instant film. Finding a workable process is not an end in itself; it is only the beginning from which a personal form of expression may flow.

The following, then, is a survey of new and exciting photo-related processes written by the artists themselves—working in a variety of media, often using personally developed techniques, and generously contributing their experience, words, and work.

Cyanotype and Drawing

An excellent example of imagery that can result from a perfect marriage of technique, materials, and expression is evidenced in the work of San Francisco artist, Sam Apple. Using cyanotype prints to create a perceptible space in which his drawings exist, Apple has achieved an exceptional integration of drawings and photo imagery in his eight-part series, *Goodbye Tenth & Folsom.*

Apple explains his idea for the series as follows: "The original reason for using the cyanotype photo process was to achieve a semitransparent illusion of a separate visual plane. By combining drawing and cyanotype, I

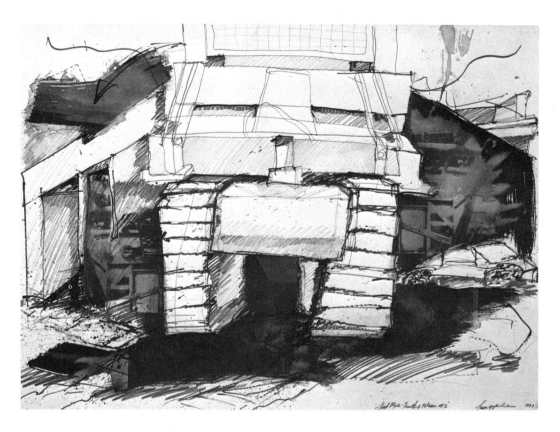

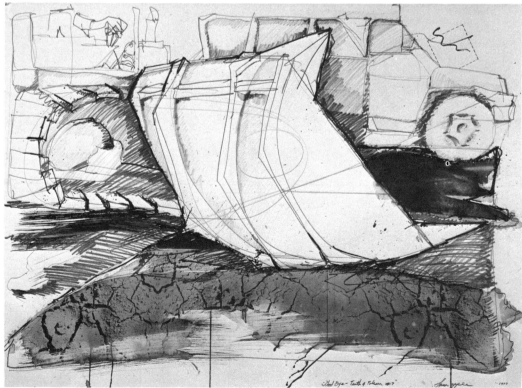

have juxtaposed the central subject with an exterior environment. These realistic images are generally linked together by the emotional concept of the piece, but do not necessarily come from the same source."

Apple's series is not only exciting on the visual level, but is technically intriguing as well. Which comes first, the images or the drawing? To clarify, he replies: "I have tried to keep the photo-image process as free as possible by applying the cyanotype as a quick wash over the line work (6B graphite) already on the paper. The gesture of the strokes of the cyanotype visually supports the line quality of the pencil, while creating another visual level of imagery to expand the three-dimensional space on the picture plane."

He further details his method for application by saying, "The tools for applying the sensitizer generally fit the scale of the strokes desired, and in most cases, I have used a 4-inch-wide, cheap paint brush. This type of brush dries quickly and does not hold the liquid, causing a multitude of dry brush marks. This texture makes an interesting contrast to the solid areas after the photo images are printed."

Apple prints the cyanotype images with a full-sized negative on high-speed duplicating film (#2575). He then exposes the image under a sun-lamp, which allows him to manipulate the print during the lengthy exposure.

Goodbye Tenth & Folsom. A series of eight pencil drawings with superimposed cyanotype imagery. 42″ × 30″ each. Artist, Sam Apple. Photographs by Bill Kane.

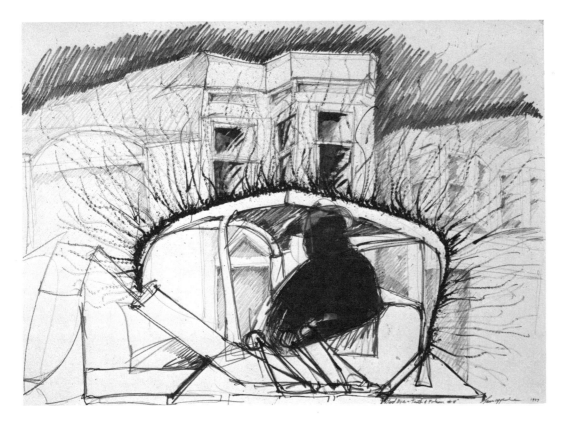

The Dalinograph

In his original approach to cameraless photography, Lon Spiegelman has perfected a technique that he used to produce photo-printed images from drawings. What is a dalinograph? Los Angeles-based Lon Spiegelman, author, fine artist, photographer, inventor of the dalinograph, and an instructor of phototype composition, describes his process as follows: "The paper negative from which the dalinograph is produced is delineated or drawn by hand. Once the negative is drawn, it can be contact-printed on light-sensitive materials and processed accordingly. No camera is needed. An enlarger is not necessary, though it can be used to projection-print film-sized hand-delineated negatives.

"Two basic elements required from the negative are paper and color. A thousand different types of paper can be used, each with different grains that will vary the texture of the printed image. And a thousand different colors can be employed, each with a unique property to either hold back or let light pass through the negative. The possibilities are endless."

left: The Fence is Always Browner on the Other Side of the Grass. Dalinograph by Lon Spiegelman for his book of the same title. 4⅞" × 7".

right: "The most profound statement has not yet been said, The picture of importance has long since been dead." Dalinograph by Lon Spiegelman from his book, *The Fence is Always Browner on the Other Side of the Grass.* 5" × 8".

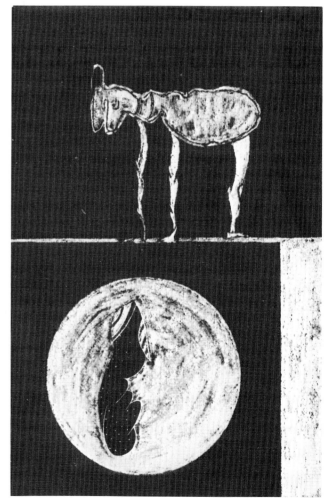

Faced with the "endless possibilities" presented with this technique, how should work begin? Spiegelman suggests, "Colored inks and colored pencils are used to draw directly on the paper that is to become the printing negative. The various colors can be likened to the density spectrum found on any photographic negative. A line drawn with black ink will let no light pass through, thus producing a white positive area. An area with no ink or color will allow the maximum amount of light to pass through the paper negative, and thus produce a black area on the positive print. The warmer colors of the spectrum, such as yellow and red, will hold back more light from passing through the paper negative than the cooler colors like blue and green. In other words, the black portions of the negative show up as white on the positive and vice versa, while all of the gradations of color used affect density of the gray tones in the final print."

In this process, the basic contact-printing method is used to print a full-sized dalinographic negative. The paper original is placed face down on a photosensitized surface (in this case, photographic paper) and held in contact during exposure. The resulting print is a reversal, making direct contact reproduction of lettering infeasible. However, projection enlargement of a dalinographic image is possible.

Spiegelman outlines his enlargement procedure: "Dalinographic prints produced via an enlarger are the most interesting and create effects that turn the artist into a true viewer of his own work. Since the pencil strokes or lines and the grain of the paper are greatly magnified, an entirely new perspective of the work is gained. The outcome of this combination of factors can result in details not visible with the naked eye.

"When a small dalinograph negative is placed in the enlarger, all photographic principles still hold true. The exposure time is increased compared to that required for the contact print on photographic paper, but this type of exposure leaves more latitude for manipulation of the projected image."

In addition to his description of the process, Lon Spiegelman's prints speak for themselves about the possibilities present in the drawn paper negative technique. His prints run the gamut from the highly textured, multidetailed imagery existing on a complex special plane in *The Fence Is Always Browner . . .* to the simpler more reserved use of line, texture, and color in *Read the Unwritten Book*. Between these extremes exists an illusionary world of dalinographic prints created by Spiegelman.

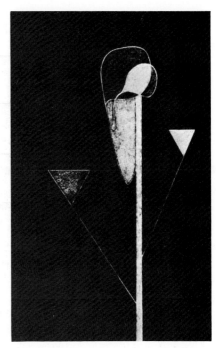

Read the Unwritten Book. Dalinograph by Lon Spiegelman from *The Fence Is Always Browner on the Other Side of the Grass.* 4¾" × 7¾".

Thermal Stencil Printing

High-contrast photo silkscreen prints are usually the product of a multiple-step procedure that begins with the creation of a film stencil from an original image on graphic arts film. To simplify this process yet achieve similar results, Wisconsin artist and teacher, Ramona Audley, uses a machine-created thermal stencil for screen printing. She explains her simple, inexpensive method as follows: "First, I choose a photograph (film original is not needed) with good contrast, or in some cases, I create my own pencil drawing for this purpose. When a photograph is to be used, the image is photocopied on a quality copying machine that will maintain the high contrast of the original.

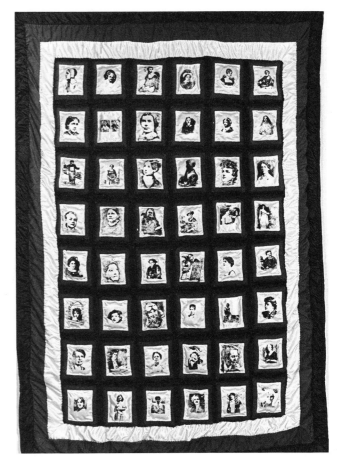

left: Fantastic Flicks (a detail) illustrates the pictorial quality obtained from a thermal stencil silkscreen print on fabric. Artist, Ramona Audley. Photograph by Mary Ann Davis.

right: Bicentennial Quilt: 47 Famous Americans and Me. Quilt created from thermal stencil prints of drawn and photo images on fabric. Artist, Ramona Audley. Photograph by Mary Ann Davis.

''The photocopied image or the original pencil drawing can then be placed on a thermal stencil (9-hole infrared thermal stencil is pink in color and available at office suppliers or from the 3M Company). The stencil and the copy are then put through a Thermofax machine as per stencil instructions. The result is that all dark areas of the image are burned out. The stencil has become a negative image that can be taped around the edges directly to the silkscreen and printed as would a regular paper stencil.''

The thermal stencil can produce a bold, high-contrast image as seen in the detail from *Fantastic Flicks*. The stencil's ability to strip away all but the essential essence of an image is exploited to its fullest in Audley's work, *Bicentennial Quilt: 47 Famous Americans and Me.* Using this technique, she has successfully combined images and photographs from various sources that would otherwise be inconsistent because of their original printing surfaces. The versatility of the thermal stencil is further demonstrated in the large repeat print on fabric, *Voyage of Love*, which contains both delicate lines and textural detail.

In addition to her thermal stencil prints on fabric, Audley has also used stencils to create photo images on ceramics. She suggests that the oxides be pressed across the screen by hand onto bisqueware that will later receive a coating of transparent glaze.

SX-70 Polaroid Alterations

Instant-image photography, from the viewpoint of the manufacturer, was meant to be the photographic system for everyone—except perhaps the serious photographer. This theory was quickly disproved by photographers and artists who viewed the instant image as a challenging new medium for self-expression.

One of the first and certainly most influential artists to discover and use the artistic possibilities of SX-70 Polaroid was Lucas Samaras. In his series, *Photo-Transformation*, Samaras approached the soft gelatin within the sealed film as he might an incomplete painting. He altered the original photo by moving entire areas and images to create a "fractured reality" in which the transformed human figure (a photo of himself) might exist.

Ardine Nelson, artist, photographer, and pioneer in Polaroid alterations, verbalizes her intrigue with the potential of the new medium: "Polaroid photography is analogous with videotape. In both cases the feedback of the recorded image is instantaneous. Because of the instant results, the imagemaker can evaluate the print and reshoot immediately. This allows for multiple frame sequencing which involves expanding the single image to multiple frame statements. The SX-70 material has no reproducible negatives; hence, unless another exposure of the same scene is immediately made, the image is one of a kind.

Untitled, 1978. Fourteen-frame SX-70 transfer print. 11″ × 9″. Artist, Ardine Nelson. Photograph by the artist.

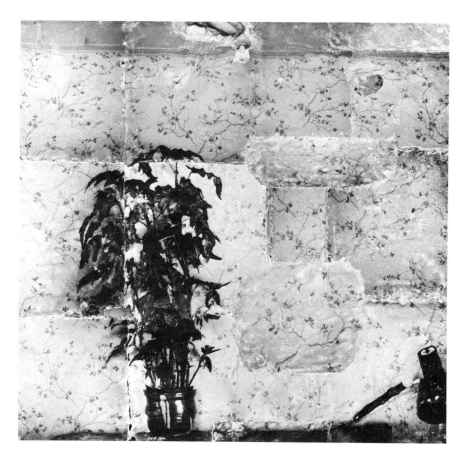

"The SX-70 print may be presented as a single image, combined in a sequence, or single images can be used to construct a larger image. Altered images may be rephotographed on SX-70 film in order to integrate the altered image into one unified image. This opens up various possibilities for two- and three-dimensional collages."

Although all techniques described by Nelson require the use of SX-70 film, photography with this film is not limited to SX-70-style cameras. However, film removed and exposed by other methods must finally be returned to an SX-70 camera for processing. Nelson explains: "It is possible to use the SX-70 film in a pinhole camera or sheet film camera, allowing for the use of the more typical camera control of exposure and lens. A pinhole camera will easily accept the SX-70 film pack. The film pack is designed in such a manner that light will strike only the top piece of film, so the film pack should be loaded into the pinhole camera in total darkness.

"After the top film sheet is exposed, the film pack must be placed into an SX-70 camera to trigger the processing chemistry built into each piece of film. Once the pack is loaded into the camera and the loading gate closed, the camera automatically ejects the top sheet. As the film passes through the pressure rollers inside the camera, the chemistry pod contained in the wide margin of the film sheet is broken and processing begins."

Ardine Nelson further explains: "A single sheet of SX-70 film may also be removed from the pack and loaded into a pinhole camera or sheet film holder for exposure. After exposure, the film is returned to the film pack, the pack is placed in the SX-70 camera, and the film sheet is ejected to begin processing. I suggest that you practice this procedure in normal light with a used piece of film and an empty film pack before you attempt it in total darkness. It would also be helpful to carefully dismantle an empty film pack to fully understand how it works.

"A sheet of film may be removed from the pack (in total darkness) by inserting a pencil in the small slot on the top-left-rear corner and gently pushing forward. The film will begin to move out of the slot at the front of the pack. Carefully pull the piece of film straight out of the pack. Caution must be taken not to break the chemistry pod contained in the wide margin of each film sheet. After exposing the film, it is replaced in the pack by first inserting one corner in the front slot, squaring up the film to the pack, and pushing it back into place. The film pack is designed with a spring to produce a small amount of pressure to move the next piece of film up for exposure in the camera. Because of this, it may be necessary to *gently* push downward on the top piece of the film in the pack while inserting the corner of the film you are replacing."

Apart from its unique ability to produce one-of-a-kind photographs, the physical characteristics of SX-70 film, with its moist chemical environment sealed in plastic, seem to invite manipulation. Although the image has developed, the film sandwich remains soft and can be altered during the first several hours after processing has begun. The length of this period of time will depend on the processing speed built into the film.

Techniques for altering the image contained in this type of film are varied. Ardine Nelson explains some of these methods: "While the film

Untitled, 1978. An image created by the transfer of two SX-70 prints onto transparent plastic. 3" × 6". Artist, Ardine Nelson. Photograph by the artist.

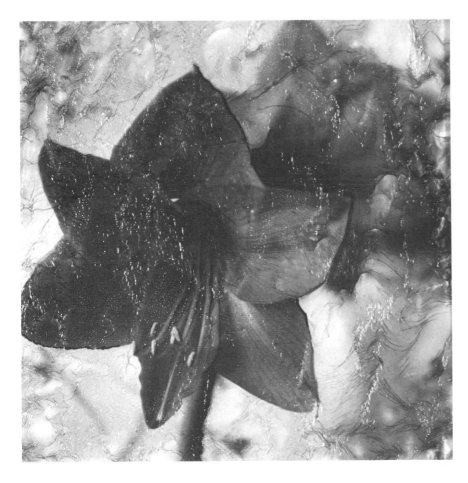

Untitled, 1978 is representative of the textural surface created when an SX-70 image is transferred onto a thin sheet of transparent plastic. 3″ × 3″. Artist, Ardine Nelson. Photograph by the artist.

remains soft, a blunt or pointed tool may be used to draw on, blend, or texturize the image. Working from the front side will leave an impression on the plastic surface, while working from the back will not. It is possible to evenly heat up an older SX-70 print and resoften the interior enough to again be able to alter the image by pressure. Heat, as well as pressure, will affect the image. A fine-tip soldering iron allows fine line control. The film may be heated in an oven or toaster during processing, which will cause the front surface to bubble, creating textures in the image. This bubble will contract when removed from the heat source. Also, waterproof felt pens and opaque acrylic paints can be used to draw on the surface of the SX-70 film.''

Exploration of the possibilities of SX-70 film is not limited to manipulating the contained image, but also includes processes in which the image is, cut, and actually split away from the sealed film sheet during early stages of processing. The culmination of this alteration is expressed in Ardine Nelson's transfer work. Using a method in which separate images may be transferred onto a second surface, she reconstructs a photographic representation of reality by transferring selected areas of several SX-70 images. The successful integration of multiple transfer of selected images can be seen in her work, *Banana Table, 1978*, created from fifteen frames of film.

Nelson warns that this procedure must be undertaken with extreme caution. It is not only a delicate process, but one that can also be hazardous. Tight-fitting surgical gloves should be worn to protect the hands. She points out, "If any material from the SX-70 film comes in contact with your skin, the area must be washed thoroughly with soap and water. If a burning sensation occurs, a weak stop bath may be used to neutralize the alkali condition. A substitute for stop bath would be any mild acid such as vinegar or orange juice."

With these precautions stated, she explains her six-step transfer method:

1. After the film is ejected and a well-defined image begins to appear, the film sheet can be separated for transfer. First, the SX-70 film sheet is cut around the border that joins the white paper to the front transparent sheet of plastic. A sharp knife blade rather than scissors is used for cutting around the edge of the plastic in order to avoid pinching the image area of the film. After the sheet is split, the opaque material, covering the back of the film, as well as the white margin around the print, are pulled away, leaving the transparent plastic layer, the white image layer, and the dark

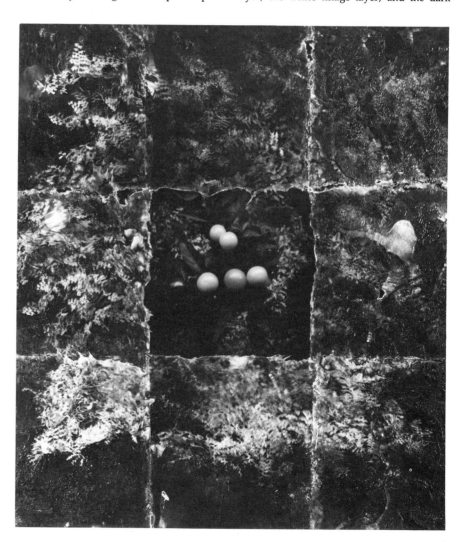

Untitled, 1977. Eight-frame SX-70 transfer composite, with one frame (center) an unaltered SX-70 photograph. 9" × 9". Artist, Ardine Nelson. Photograph by the artist.

chemistry layer exposed. This separation of the opaque backing from the dark chemistry layer must occur at the time (established by experimentation) during processing in which the layers can be pulled apart without damaging the image. If the layers are pulled apart too soon, the black layer will migrate into the white, causing texturing of the image that will make transfer impossible.

2. After the backing paper has been successfully removed, the remaining film should contain the transparent plastic layer, the white image layer, and the black chemistry layer. The image is placed face down, and the dark chemistry is removed from the white image layer. This is accomplished by applying warm water (100–110°F) and rolling the chemistry back on itself with a cotton swab. Care must be taken during this procedure. If too much water or pressure is applied directly, the white layer will dissolve and eliminate the image.

3. After removing the dark layer, the image is ready for transfer. To adhere the image, the white layer is dampened with warm water and placed image side up on the receiving surface. The front plastic layer is gently rubbed to transfer the image. By using a paper towel and even hand pressure, distortion or blending of the image will be minimized. During this procedure, the white layer containing the image will usually spread beyond the edge of the front plastic, making the separation of these two layers less difficult. Just before the front plastic layer is removed, the edges are burnished to ensure a strong bond between the image and the receiving material. A rounded, smooth nut pick is quite useful for burnishing small areas, or a teasing needle (ceramic tool) might also be used.

4. To complete the transfer process, the front plastic layer is peeled away. The best tool for this is the teasing needle. By starting at one corner and pushing the point of the needle between the plastic and the image, the plastic layer can be lifted. The loosened corner of plastic is held while working around the edges with the needle. Often the separation can be immediate. However, if the image sticks to the plastic, apply pressure from on top of the plastic and then try lifting the plastic again. The teasing needle can aid in holding down the image while pulling upward on the plastic with your fingers. It is most important that the image is stuck down around the edges. The image may pull away and bubble up in the central area. Prick the bubble with the teasing needle and it will deflate and lie flat.

If the front plastic is not separated soon enough, the image will become permanently bonded to it. This bond occurs first in the darkest image areas. This process, as outlined, may become more difficult as Polaroid speeds up the development time of SX-70 film.

5. The white emulsion containing the transferred image will be soft for a short period of time. Moisture will resoften the image, allowing for stretching and overlapping with other images. The teasing needle may be helpful in moving the soft image around.

6. Any excess white material adjoining the image may be washed away with warm water. The white image layer will adhere to almost any surface after it has been dampened with water. I have transferred to glass, plastic, and various photographic papers. The emulsion takes on a painterly, textured surface. Additional color may be applied to the surface with color or felt-tip marking pens. The final print can be mounted with an ultraviolet filtering Plexiglas cover to replace the film's built-in filter that was removed during transfer.

Although Nelson prefers to use the method described for her own work because of the surface texture that results, she adds that an image can be transferred with the dark chemistry layer intact. For this process, a fast-drying spray adhesive sold in photo supply stores for mounting photographs can be used to bond the chemistry to the transfer surface. The front plastic layer may also be kept intact.

She concludes: "The only limiting factor in using SX-70 materials is your imagination! Experiment with the SX-70 material before passing aesthetic judgments about the images. In the end, the process or materials the image-maker employs should support, not dominate the image."

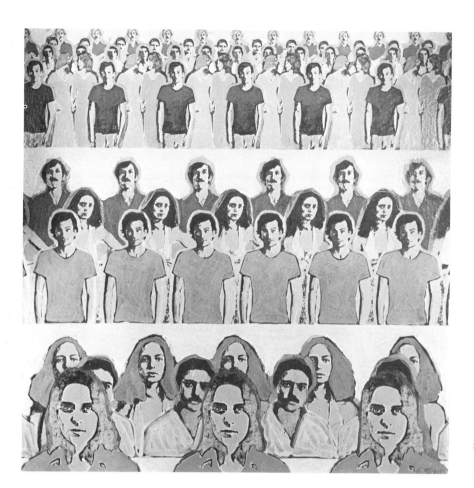

Crowd Scene #3. Photo-collage created from actual photographs mounted on canvas and painted with acrylic. 26″ × 26″. Artist, Greg Spaid.

Mixed-media Photo-collage

Photo-collages take many forms as techniques evolve to fulfill the artist's personal vision. This is evident in the work of Greg Spaid, who combines photography with painting to achieve the lyrical quality he desires in his "fugal" compositions.

Artist and instructor of art at Berea College (Berea, Kentucky), Spaid describes his work: "I like to think that I am using photographic images as a way of simply making marks, marks which are inherently different from the marks I make with my hand. I hope a certain tension results from the association of these two types of marks and that neither the photographic qualities nor the painterly quality dominate the work. I am also trying to achieve a union (created through tension between opposites) of the specific reality of the photographic marks and the more lyrical quality of loose heavy paint."

This lyrical relationship between textured paint and imagery can be seen most vividly in Spaid's *Untitled, 1978.* Here the patterns apparent in the photo images of clothing work harmoniously with the textured paint in areas of solid color. The balance between foreground and background is controlled by the color as well as the placement of shapes so that positive

and negative space become seemingly interchangeable, creating a feeling of movement on the picture plane.

When asked how his unique collage technique developed, Spaid explained, "I turned to collage about a year ago because I was too poor to buy materials I needed for straight color photography. My method is simple and cheap. I have quick, inexpensive offset black-and-white prints made from my photographs. I then arrange these prints and paste them to canvas or paper, and paint on them with acrylic. I enjoy this method because it is direct and immediate. No waiting for the latent image to be realized."

Burn-out Printing on Fabric

Printing the surface of fabric with a raised photo-relief image without ink or flocking is not the result of witchcraft, but the product of the burn-out printing process. The burn-out process uses chemicals rather than color to record an image. It is based on the ability of certain chemicals to dissolve or burn away screen-printed portions of a multifiber fabric. Although this technique has long been known and used by textile printing industries, its adaptation to the art of creating images on fabric is recent. James R. Gilbert, a metropolitan Detroit-area artist and textile designer, has been an innovator in the exploration of the potentials of this process as a creative medium.

Pictorially, the burn-out, or Devore print can be compared with a photo etching, and technically there are similarities: both prints are produced by the action of acid that eats into the surface causing a relief pattern. However, the acid necessary for the burn-out is not contained in the original chemical solution; rather, it is a product created when the printed fabric is subjected to heat. This is the most critical and hazardous stage of the process. Gilbert, who has achieved outstanding results with this method, warns: "During the heating process, the chemical structure of the aluminum sulfate changes to sulfuric acid vapor. *Be sure to wear a respirator mask and work in a room ventilated directly to the outside.* Old ovens not used for food preparation are recommended for the burn-out process."

Having warned of the burn-out procedure, Gilbert offers the following formula for preparing the printing paste for silkscreening: "15 to 20 percent aluminum sulfate (a blue coloring agent used by nurseries for coloring flowers), 5 percent glycerine (available from a drugstore), 30 percent stock solution of mannogalactan ether, commonly known as bean gun (available from mail order dye suppliers), and water are added to achieve the correct syrupy consistency.

"First, the stock solution of mannogalactan ether is mixed. Add $\frac{1}{2}$ cup of warm water to two tablespoons of mannogalactan ether. Using a blender, mix for several minutes until components are well blended and the substance has swelled. Allow this mixture to set for four hours at room temperature. After four hours, the mixture should still have a flowing, syrupy consistency. Add more water and blend again if the mixture seems too thick. (This stock solution will last for two months if stored in the refrigerator.)"

The printing paste can be prepared after the stock solution is ready. Gilbert describes: "First mix the aluminum sulfate and glycerine in a medium-sized bowl (ceramic or glass) that can be cleaned thoroughly. Add 30 percent of the stock solution of mannogalactan ether into this mixture. Finally, add enough water to make the mixture fluid and syrupy.

"The photo silkscreen is prepared from a nonwater-soluble film image. I use NazDar Bluestar Emulsion and apply the paste with a specially designed tool called a trough that distributes the emulsion evenly over the surface of the screen."

When a positive relief image is desired on the fabric, the screen is prepared with a negative image. The reverse is also true. If a positive image is screened onto the fabric, a negative, raised image will remain after burn-out.

Gilbert specifies that a cellulosic fabric such as cotton velvet be used for this process. His *Floating Clouds—Cherry Blossom Tree* illustrates the definition that can be obtained when a cotton velvet is burned out, leaving the unprinted portion of the fabric in relief.

After the printing paste has been screened onto the fabric and allowed to dry completely, the actual burn-out is undertaken. James Gilbert describes this procedure: "The oven is preheated to 360°F. The fabric is attached to a wire oven rack with printed side down using wooden clothespins to hold it firmly in place. Once the temperature reaches the correct level, the rack holding the fabric is placed in the uppermost position in the oven. As the fabric is heated, sulfuric acid vapors are formed. A respirator mask, specified safe for this type of vapor, is worn throughout this procedure. It is particularly hazardous if the oven door must be opened to check the progress of the burn-out. The vapor caused by the chemical reaction is whitish in color and must not be inhaled. If the oven has a window, the color of the fabric can be observed, and the burn-out process monitored. After approximately thirty seconds, the color should change in the printed area to a light brown, indicating that burn-out has taken place. If there is no window, the oven door should be opened after the first thirty seconds. If the color has not changed, the oven is closed and heating is continued for another fifteen seconds. As the burn-out continues, the fabric must be checked after each fifteen-second interval to avoid overheating. The fabric can catch fire if allowed to remain in the oven longer than necessary for burn-out.

"If the fabric is a dark brown or black in the printed area, this indicates overheating. Ovens vary in temperature readings and heating methods, so visual timing is the best way to gauge burn-out. For this reason, the breathing mask is essential. Also, vapors can continue to be emitted by the fabric even after it leaves the oven. Cool in a well-ventilated area.

"Once the burn-out is complete, the fabric is washed with water to remove the carbonized area of the cellulosic fabric. After washing, cotton velvet should be placed in a dryer on a low setting to fluff the fabric so as to achieve maximum relief in the print."

Although washing away the carbonized portion of the fabric after burn-out is recommended, it is not absolutely essential in all cases. Gilbert's *Winter Images* is an example of a burn-out print in which the carbonized areas were retained to create a two-color composition.

below left: Floating Clouds—Cherry Blossom Tree. Burn-out print on cotton velvet with carbonized areas washed away. 11″ × 9″. Artist, James R. Gilbert. Photograph by the artist.

right: Winter Images. Burn-out print on cotton velvet with carbonized areas (dark images) retained. 24″ × 12″. Artist, James R. Gilbert. Photograph by the artist.

below right: Searching for X. Fabric hand-loomed by artist of cotton and polyester yields a burn-out print quite different in quality from those created on commercial fabrics. 28″ × 15″. Artist, James R. Gilbert. Photograph by the artist.

In addition to creating burn-out prints on commercial fabrics, Gilbert has further explored the potential of the process by creating hand-woven fabric for use in his design. Using a combination of cotton and polyester fibers for weaving, he is able to expose the underlying weblike structure of the fabric with this process. The resulting print, with its open areas of fragile detail, produces an illusion of space quite different in feeling from images printed on velvet. In *Searching for X*, color is controlled by the background on which the sheer portion of the image rests. The dark color that defines the radiating shapes is that of the wall on which the hanging is placed.

Conclusion

Photographic images provide the catalyst that inspires the artist to cross arbitrary boundaries that once separated art and photography. Through an exploration of old and new photo related processes, the artist gains the tools and knowledge to expand and perfect his or her vision within a chosen medium. It is hoped that this book will help supply the information needed for the artist to transform an idea into a personally satisfying work of art.

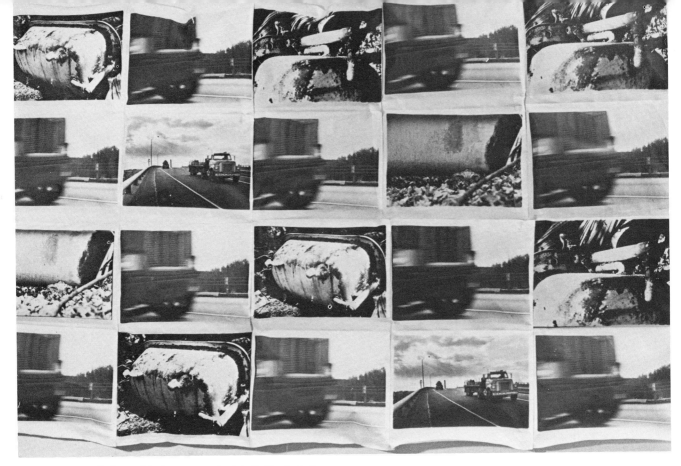

The bathtub quilt *Route 9A,* is composed of individual photos printed on emulsion-sensitized linen and stitched together. 5'5" × 3'3". Artist, Amy Stromsten.

Supply Sources

CHAPTER III

Custom fabrication of photographic decals:

Philadelphia Ceramic Supply
 1666 Kinsey Street
 Philadelphia, PA 19124

Battjes Decals
 5507 20th Street W.
 Bradenton, FL 33507

Decal paper and fabrication supplies:

Advance Process Supply
 400 N. Noble Street
 Chicago, IL 60622
 (Sales offices in major cities)

Ulano
 210 E. 86th Street
 New York, NY 10028

Local graphic arts or photo suppliers:

Dye transfer paper:

Straw Into Gold
 P.O. Box 2904
 5533 College Avenue
 Oakland, CA 94518

Cerulean Blue, Ltd.
 P.O. Box 5126
 1314 N.E. 43rd Street
 Seattle, WA 98105

Inks for printing dye-transfer paper:

Transcello Inks
 Advance Process Supply
 400 N. Noble Street
 Chicago, IL 60622

Transfer sheets for electrostatic transfer:

Quick-Way Color Copies
 100 East Ohio
 Chicago, IL 60611

CHAPTER IV

Custom development of large negatives:

Local commercial printing firms with large copy cameras.

Chemicals:

Potassium ferricyanide—Kodak product available at photo supply stores.

Potassium dichromate—Kodak product available at photo supply stores.

Tannic acid—local drugstore or winemaking supply stores.

All other chemicals can be obtained from large firms that supply chemicals for scientific use, such as

Sargent-Welch Scientific Company
 7300 North Linder Avenue
 Skokie, IL 60067

Student Science Service
 622 West Colorado Blvd.
 Glendale, CA 91200

See telephone directory for nearest listing.

Prepackaged sensitizers:

Rockland Fabric Sensitizer FA-1:

Rockland Colloid Corporation
 302 Piermont Avenue
 Piermont, NY 10968

Kwik-Print:

Light Impressions
 P.O. Box 3012
 Rochester, NY 14614

Inkodye:

Screen Process Supplies
 1199 East 12th Street
 Oakland, CA 94606

Inkodye, blueprint kit, brownprint kit, and fabrics for printing:

Cerulean Blue, Ltd.
 P.O. Box 5126
 1314 N.E. 43rd Street
 Seattle, WA 98105

Cyanotype kit:

R & J Arts, Inc.
 4821 South 1395 East
 Salt Lake City, UT 84117

Cyanotype, blueprint, and brownprint kits, and prewashed fabrics:

D.Y.E.
 3763 Durango Avenue
 Los Angeles, CA 90034

Unsized fabrics for contact printing:

Testfabrics
 P.O. Box 118
 200 Blackford Avenue
 Middlesex, NJ 08846

CHAPTER V

Projection-speed emulsion:

Porter's U-Spread Emulsion
 Porter's Camera Store, Inc.
 P.O. Box 628
 Cedar Falls, IA 50613

Projection-speed emulsion, silkscreen emulsion, and presensitized aluminum:

Rockland Colloid Corporation
 302 Piermont Avenue
 Piermont, NY 10968

Photo linen:

Luminos
 25 Wolffe Street
 Yonkers, NY 10705

Photo ceramic kit for firing:

Picceramic Company
 817 Ethel Place
 Vestal, NY 13850

Silkscreen inks and supplies:

Ulano
 210 East 86th Street
 New York, NY 10028

Advance Process Supply
 400 N. Noble Street
 Chicago, IL 60622
 (Sales offices in major cities)

Cincinnati Screen Process Supply Company
 1111 Meta Drive
 Cincinnati, OH 45237

Naz Dar Company
 1087 North Branch Street
 Chicago, IL 60622

Bibliography

CHAPTER I

History of Photo Images in Art

Arts Council. *The Real Thing, An Anthology of British Photographs 1840–1950.* London: Arts Council of Great Britain, 1975.

Coke, F. Van Deren. *One Hundred Years of Photographic History.* Albuquerque: University of New Mexico Press, 1975.

————. *The Painter and the Photograph.* Albuquerque: University of New Mexico Press, 1970.

Gernsheim, Helmèt, Gernsheim, Alison. *A Concise History of Photography.* New York: Grossett and Dunlap, 1965.

Jussim, Estelle. *Visual Communications and the Graphic Art; Photographic Technologies in the 19th Century.* New York: R. R. Bowker, 1974.

Lewis, Steven, McQuaid, James, Tait, David. *Photography Source and Resource.* Pennsylvania State College: Turnip Press, 1973.

Newhall, Beaumont. *The History of Photography from 1839 to the Present Day,* rev. ed. New York: Museum of Modern Art, 1964.

————. *Latent Images: The Discovery of Photography.* Garden City, New York: Doubleday, 1967.

Pollack, Peter. *The Picture History of Photography.* New York: Harry N. Abrams, 1969.

Rudisill, Richard. *Mirror Image: The Influence of the Daguerreotype on American Society.* Albuquerque: University of New Mexico Press, 1971.

Sontag, Susan. *On Photography.* New York: Farrar, Straus and Giroux, 1977.

Taft, Robert. *Photography and the American Scene: A Social History.* Magnolia, Massachusetts: Peter Smith Publishers, Inc., 1938. New York: Dover, 1964.

Thomas, Dr. D. B. *From Today Painting Is Dead: The Beginning of Photography.* London: The Victoria and Albert Museum and The Arts Council of Great Britain, 1972.

Welling, William. *Collectors' Guide to 19th Century Photographs.* New York: Collier Books, 1976

CHAPTER II

Designing with Photo Images

Ades, Dawn. *Photomontage.* New York: Pantheon Books, 1976.

Eastman Kodak Company. *Basic Color for the Graphic Arts.* Rochester, New York: Eastman Kodak Company, 1977.

Elam, Jane A. *Photography: Simple and Creative; with and without a Camera.* New York: Van Nostrand Reinhold, 1975.

Gassan, Arnold. *Handbook for Contemporary Photography,* 4th ed. Rochester, New York: Light Impressions, 1978.

Hedgecoe, John. *The Book of Photography* New York: Alfred A. Knopf, 1976.

Kostelanetz, Richard. *Moholy-Nagy.* New York: Praeger, 1970.

Langford, Michael J. *Basic Photography.* New York: Amphoto, 1965.

————. Advanced *Photography.* New York: Amphoto, 1972.

Moholy-Nagy, Laszlo. *Painting, Photography, Film.* Cambridge, Massachusetts: M.I.T. Press, 1967.

Pittaro, Ernest M., ed. *Photo-Lab-Index.* Dobbs Ferry, New York: Morgan & Morgan, 1976.

Rubin, William S. *Dada, Surrealism and Their Heritage.* New York: Museum of Modern Art, 1968.

Snyder, Norman. *The Photography Catalog.* New York: Harper & Row, 1976.

Swedlund, Charles. *Photography, A Handbook of History, Materials and Processes.* New York: Holt, Rinehart and Winston, 1974.

Vestal, David. *The Craft of Photography.* New York: Harper & Row, 1975.

Wescher, Herta. *Collage.* New York: Harry N. Abrams, 1968.

Woell, J. Fred, ed. *Photography in the Crafts.* Deer Isle, Maine, 1974.

Zakia, Richard D. *Perception and Photography.* Englewood Cliffs, New Jersey: Prentice-Hall, 1975.

CHAPTER III

Transfer-Printing Processes

Biegeleisen, J. L. *The Complete Book of Silk Screen Printing Production.* Chapter 12, "Decals." New York: Dover, 1963.

Cyr, Don. "Peel Off and Put On." *Design* (Mid-winter 1973): 10–13.

Firpo, Patrick, Alexander, Lester, Katayanagi, Claudia. *Copyart.* New York: Richard Marek Publishers, 1978.

Kaplan, Jonathan. "Making Ceramic Decals!" *Ceramics Monthly* (April and May 1975).

Kosloff, Albert. *Ceramic Screen Printing.* Cincinnati: Signs of the Times Publishing Company, 1962.

Murray, Joan. "People and Machine." *Artweek* (September 22, 1973): 11.

Reichman, Charles. *Transfer Printing Manual.* New York: National Knitted Outerwear Association, 1976.

Saff, Donald, Sacilotto, Deli. *Printmaking: History and Process.* New York: Holt, Rinehart and Winston, 1978.

Stevens, Harold. *Transfer: Designs, Textures and Images.* Worcester, Massachusetts: Davis Publications, Inc. 1974.

Williams, Alice. "Jill Lynne—Collage to Create Machine Art." *Popular Photography* (March 1977): 88–91.

CHAPTER IV

Contact-Printing Processes

Adrosko, Rita J. *Natural Dyes and Home Dyeing.* New York: Dover, 1971.

Bayley, R. Child. *The Complete Photographer,* 11th ed. London: Methuen, 1935. 1935.

Brooklyn Botanic Garden Record. *Dye Plants and Dyeing—A Handbook,* vol. 20, no. 3. Brooklyn, New York, 1964.

Bunnel, Peter C., ed. *Nonsilver Printing Processes: Four Selections, 1886–1927.* New York: Arno Press, 1973.

Davis, William S. *Practical Amateur Photography.* New York: Garden City Publishing Company, 1937.

Eastman Kodak Company. *Creative Darkroom Techniques.* Rochester, New York, 1973.

————. "Photographic Sensitizer for Cloth and Paper." *Pamphlet #AJ-5.* Rochester, New York.

Focal Encyclopedia of Photography, vol. I, "Fabric Printing," p. 573. London: Focal Press, 1965.

Mack, J. E., Miles, J. Martin. *The Photographic Process.* New York: McGraw-Hill, 1939.

Matthews, J. Merritt. *Application of Dyestuff to Textile, Paper, Leather and Other Materials.* New York: John Wiley, 1920.

Morgan, Willard D. *The Complete Photographer: An Encyclopedia of Photography.* New York: National Educational Alliance, 1942.

Rexroth, Nancy. *The Platinotype,* 2nd ed. Yellow Springs, Ohio: Violet Press, 1977.

Wall, E. J. (revised by Franklin I. Jordan). *Photographic Facts and Formulas.* Boston: American Photographic Publishing Company, 1940.

CHAPTER V

Emulsion-Printing Process

Bartel, Marvin. "Silk Screening with Slip," *Ceramics Monthly* (March 1973): 26–31.

Campana, D. M. *Photo Ceramics.* Chicago: D. M. Campana Company, 1945.

Eastman Kodak Company, "Making a Photographic Emulsion." *Pamphlet #AJ-12.* Rochester, New York.

Kosloff, Albert. *Screen Printing Techniques.* Cincinnati: Signs of the Times Publishing Company, 1972.

Neblette, Carrol B. *Neblette's Handbook of Photography and Rephotography: Materials, Processes and Systems,* 7th ed. New York: Van Nostrand Reinhold, 1976.

Nettles, Bea. *Breaking the Rules: A Photo Media Cookbook.* Rochester, New York: Light Impressions, 1977.

Roebuck, John R. *The Science and Practice of Photography.* New York: Appleton & Company, 1928.

Scully, Ed. "Beyond the Negative." *Modern Photography* (November 1975): 76.

Woodbury, Walter E. *Photographic Amusements.* Boston: American Photographic Publishing Company, 1937.

Zucker, Harvey. "Print Your Wagon." *35 mm Photography* (Summer 1973): 28–31.

CHAPTER VI

Innovative Printing Processes

"Evolution of Polaroid One-Step Photography." *Camera* 53, no. 11 (October 1974): 49.

Glenn, Constance W., ed. *Lucas Samaras: Photo Transformation.* New York: E. P. Dutton, 1975.

Hollen, Norma, Saddler, Jane. *Textiles,* 3rd ed. New York: Macmillan, 1968.

Krims, Les. *Fictcryptokrimsographs.* Buffalo, New York: Les Krims, 1975.

Purcell, R. W. "Art with Instant Film." *Modern Photography* (July 1975): 84–93.

Robinson, Stuart. *History of Printed Textiles.* Cambridge, Massachusetts: M. I. T. Press, 1969.

Spiegelman, Lon. *The Fence is Always Browner on the Other Side of the Grass.* Los Angeles, 1970.